August 19, 2006

Dear John,

Best wishes on your 60th birthday! Hope you have time
soon to explore the coast of Maine and find many of
the chairs featured in these photographs. The bottle of
champagne would be a nice complement to the chairs!

Jan and Ed

A Seat on the Shore

quietly admiring the Maine coast

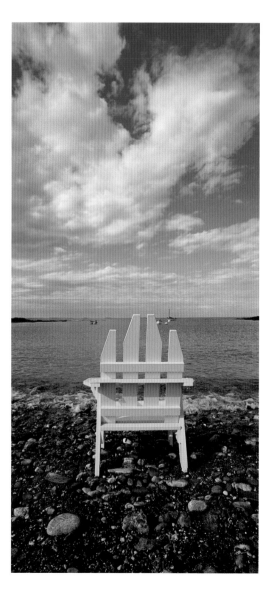

Photographs by
Nance Trueworthy

foreword and captions by David Tyler

Down East Books
Camden, Maine

Dust-jacket design by Lindy Gifford
Interior design by Phil Schirmer

Printed in China

5 4 3 2 1

ISBN 0-89272-665-2
Library of Congress Control Number: 2004116481

Down East Books
P.O. Box 679
Camden, ME 04843
A division of Down East Enterprise, publishers
of *Down East* magazine

For catalog information and book orders, call
1-800-685-7962, or visit www.downeastbooks.com

*Front cover photo: Sunrise illuminates the porch at the Grey Havens Inn,
Georgetown Island.*

*Back cover photo: A rainbow complements Spring Point Light,
South Portland.*

With much love to my sister, Lynne. Thank you for always being there.

In memory of my Polish grandmother, who taught me the importance of acts of kindness and love.

And finally to my "other family"—The Gang—with love for all the times we have shared.

—N.T.

oreword

Exploring the Maine coast is like going on a statewide treasure hunt. On every trip you make, you find a new jewel: a secluded beach, a Victorian inn by the shore, or a fishing wharf with a mélange of skiffs tied to it and lobster boats moored out in the harbor.

Nance's seaside images convey that sense of discovery, a sense that she's sharing intimate, serene places that no one else knows about. Her images invite us into contemplative spots, places where we can leave our harried lives behind and just sit, wondering at the beauty of this shore.

There's a lot to explore here. Maine's coast, with all its indentations, is about thirty-five hundred miles long, and there are more than six thousand islands just offshore. Much of the coastline consists of peninsulas that reach out into the ocean and of beaches and fishing villages tucked away in bays and harbors. Incredibly, despite all the visitors that come to Maine every summer, many people don't bother to leave Route 1 and seek out these special places.

That's the joy of Nance's photography. She has lived in Maine for thirty years, and she knows nearly all of its shoreline. In this book, you'll make a trip down Route 24, to the historic Cribstone Bridge that links Orrs Island and Bailey Island. You'll drive along Route 27, take a left-hand turn in Boothbay Harbor, head south on Route 96 through East Boothbay, and find yourself in the magic of Ocean Point. You'll turn right off Route 1 in Woolwich and travel

south on Route 127, which winds through Arrowsic Island and Georgetown Island, before ending at the fishing village of Five Islands. Nance will also take you to tucked-away places like Cozy Harbor, Port Clyde, and Capitol Island.

But she also brings a special perspective to spots such as Mackworth Island, near Portland, or Seawall Beach, on Mt. Desert Island, that are visited by thousands of people each year. Nance shows us these places, places that we think we already know, in a new light. In one photo, we see beach grass near Mackworth Island in the brilliant light of a late-fall afternoon. In another image, we see a summer fog lifting off the glittering stones on Seawall Beach.

We see these popular places as if they're new. And that's Nance's gift. She brings a freshness and wonder to all that she photographs. It's a philosophy we can learn from. Those of us who live in Maine sometimes take the beauty of our state for granted. Nance reminds us all— whether we spend the year here or come visit the coast every summer—that there's always something new to find and to cherish.

So pick up this book and join Nance for a trip along the Maine coast. We're going to put our map away, turn off Route 1, and head down a peninsula seeking back roads and new spots along the shore, places where we can stop, take a seat, and reflect on the loveliness of this timeless place.

David Tyler
Warren, Maine

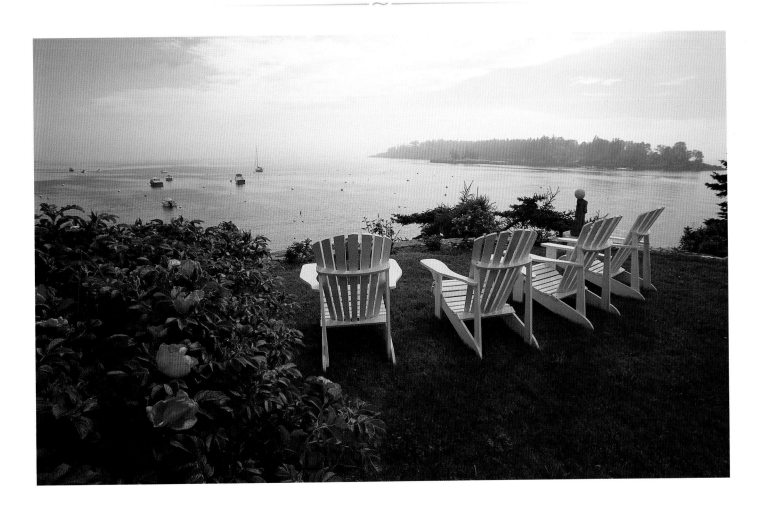

OCEAN POINT, EAST BOOTHBAY.

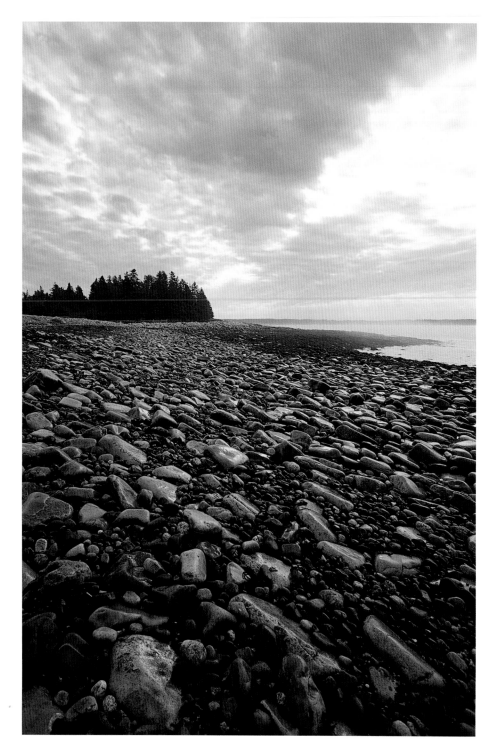

LOW TIDE AT SEAWALL,
MT. DESERT ISLAND.

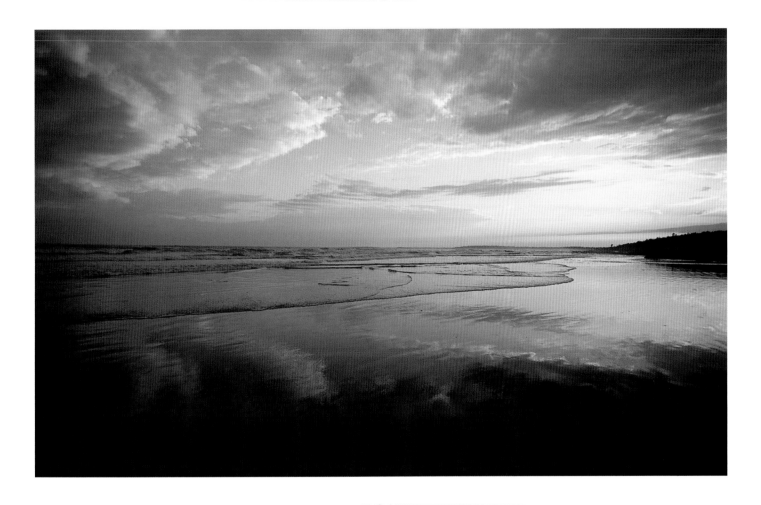

SUNSET AT HIGGINS BEACH, SCARBOROUGH.

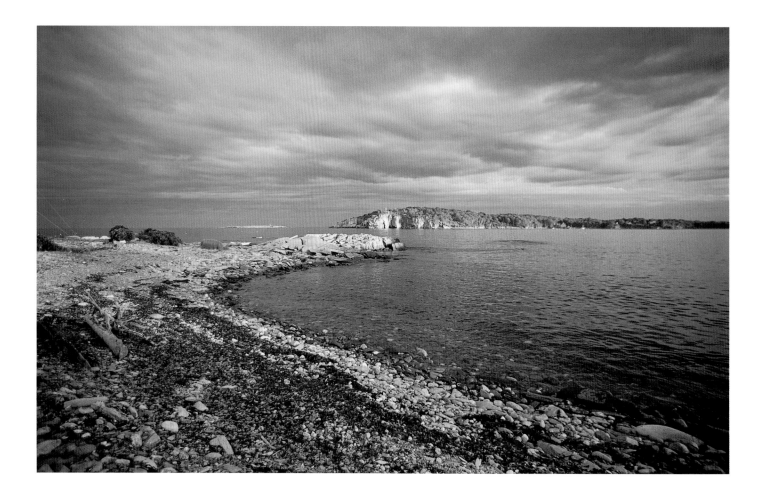

WHITEHEAD PASSAGE, FROM PICNIC POINT ON PEAKS ISLAND.
THE PROFILE IN THE CLIFFS ON CUSHING ISLAND IS CALLED
"THE OLD MAN OF CUSHING."

A SOLITARY STARFISH AT
LOW TIDE IN OGUNQUIT.

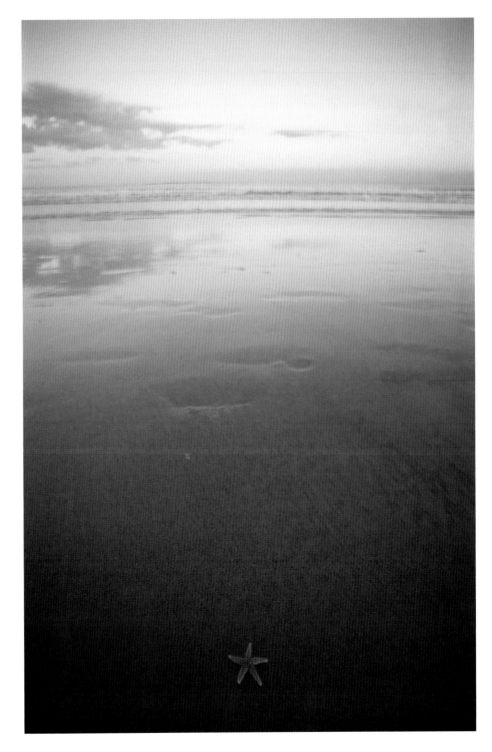

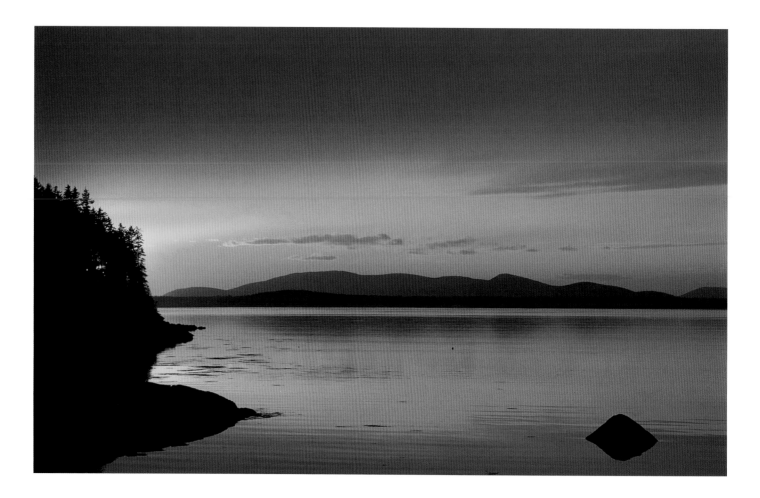

A VIEW OF THE CAMDEN HILLS AT SUNSET.

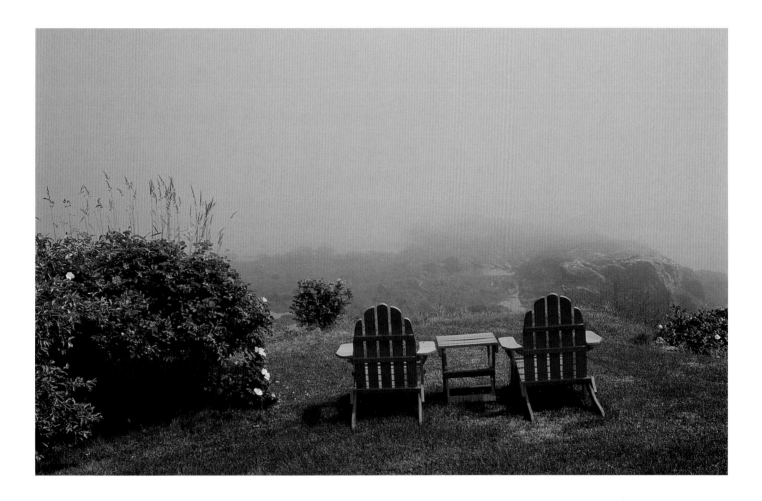

A FOGGY DAY, CAPE ELIZABETH.

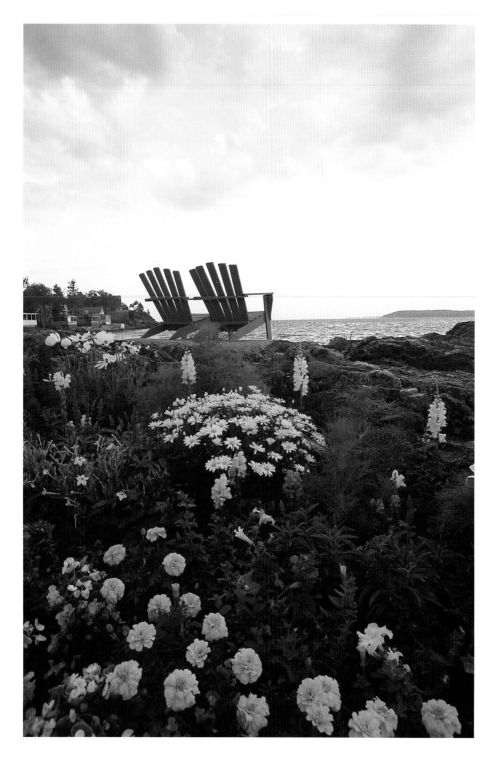

THE HEIGHT OF THE
BLOOM AT THE
OCEAN POINT INN,
EAST BOOTHBAY.

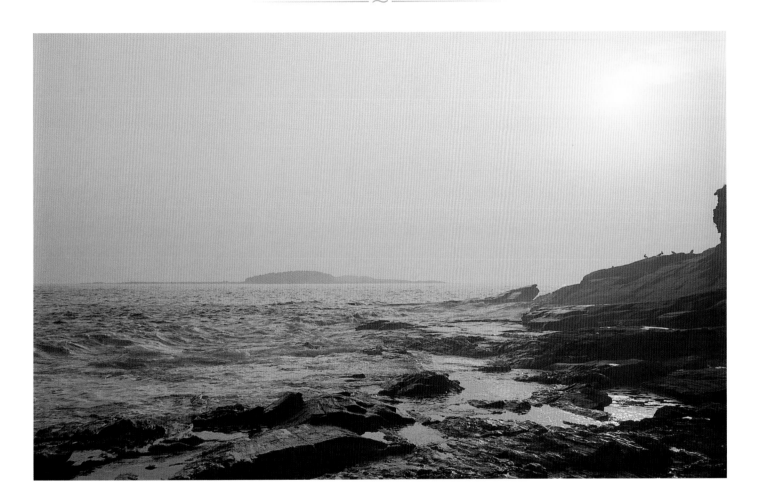

TWO LIGHTS STATE PARK, CAPE ELIZABETH, WITH RICHMOND ISLAND IN THE BACKGROUND.

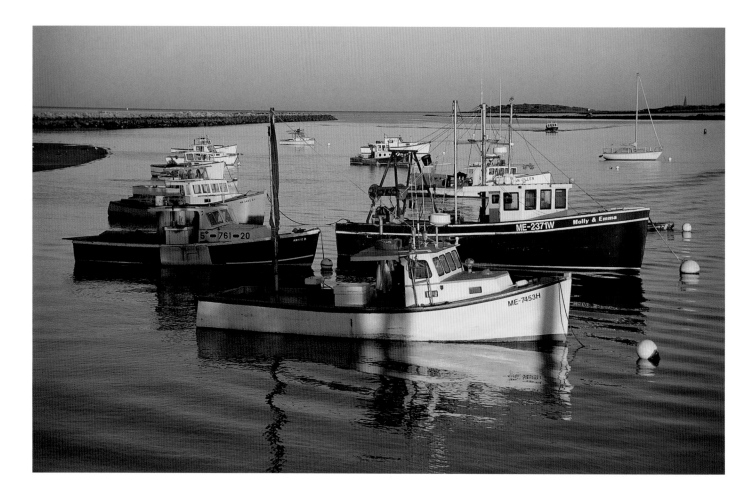

LOBSTER BOATS MOORED AT CAMP ELLIS IN THE LATE AFTERNOON.

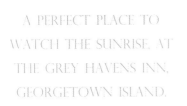

A PERFECT PLACE TO
WATCH THE SUNRISE, AT
THE GREY HAVENS INN,
GEORGETOWN ISLAND.

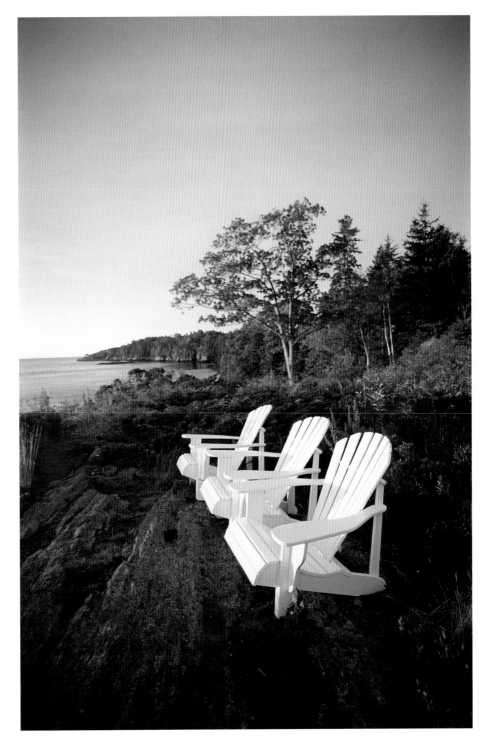

19

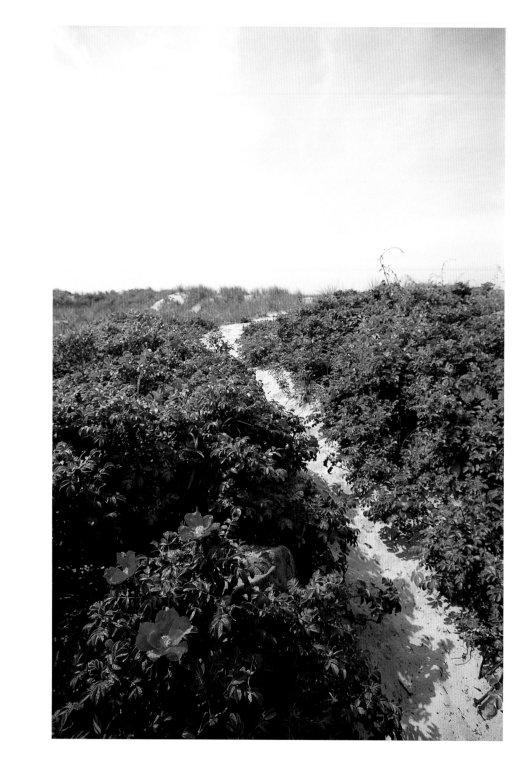

RUGOSA ROSES ALONG
A BEACH PATH,
GOOSE ROCKS BEACH,
KENNEBUNKPORT.

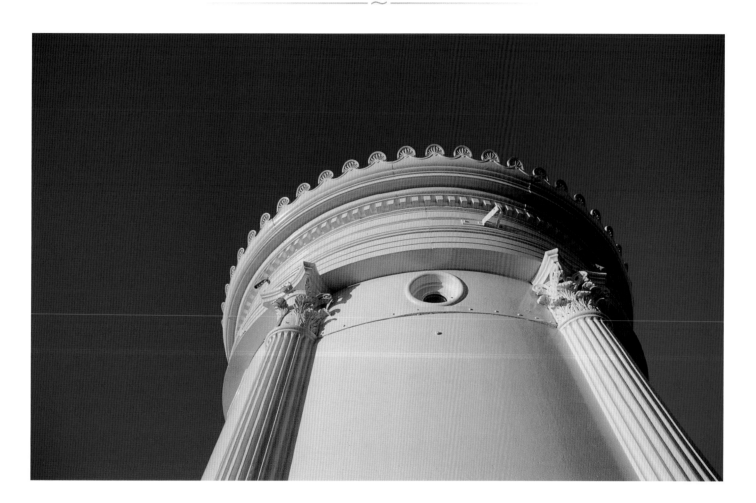

PORTLAND BREAKWATER LIGHT, SOUTH PORTLAND. KNOWN AS "BUG LIGHT," IT WAS FIRST LIT IN 1875. THE LIGHTHOUSE'S UNUSUAL DESIGN WAS MODELED AFTER THE MONUMENT OF LYSICRATES, BUILT IN THE FOURTH CENTURY B.C. IN ATHENS, GREECE.

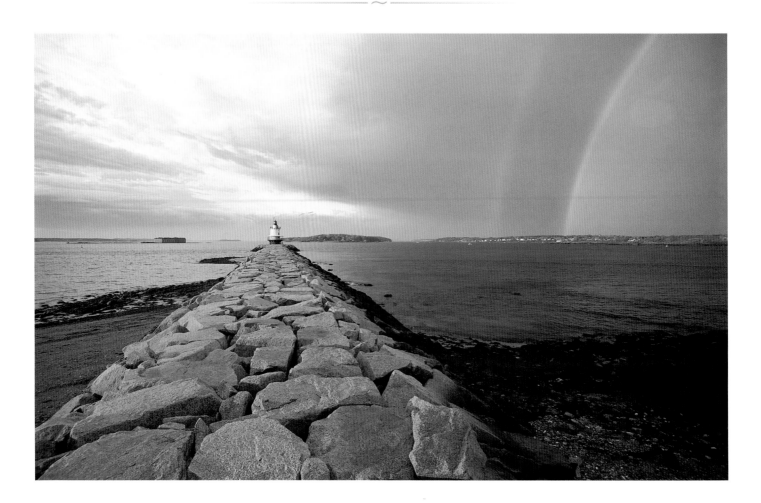

A RAINBOW COMPLEMENTS SPRING POINT LIGHT, SOUTH PORTLAND

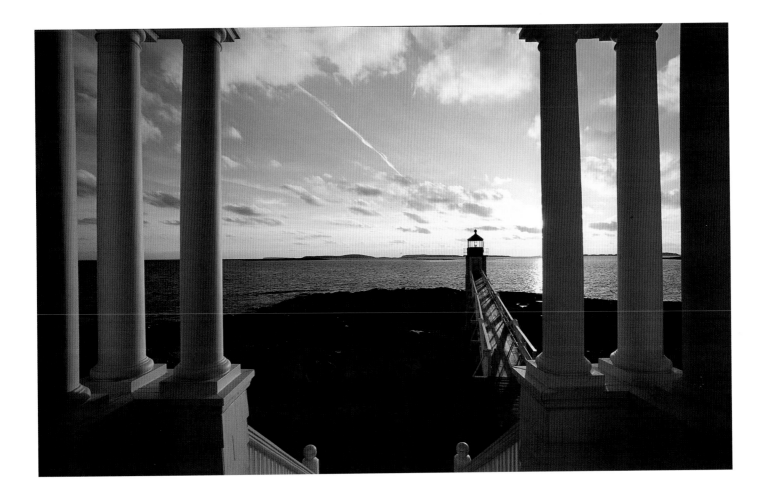

LATE AFTERNOON AT MARSHALL POINT LIGHT, PORT CLYDE.

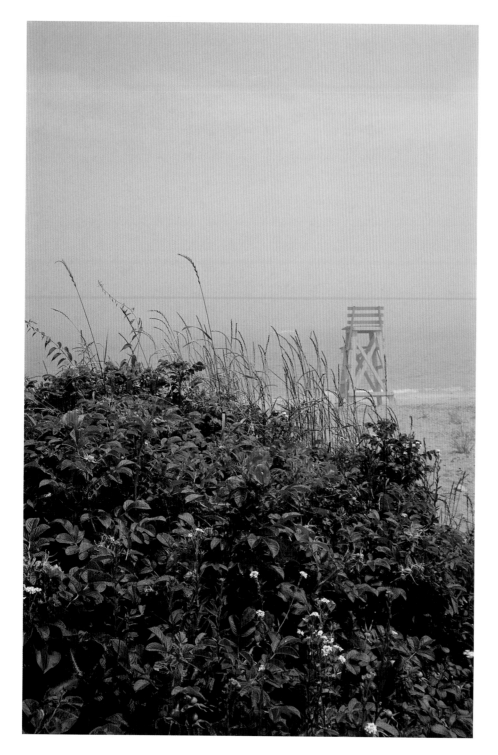

RUGOSA ROSES AT WILLARD
BEACH, SOUTH PORTLAND.
THESE SHRUBS ARE ALSO
KNOWN AS BEACH ROSES
BECAUSE THEY ARE SO
COMMON ALONG THE
MAINE SHORE.

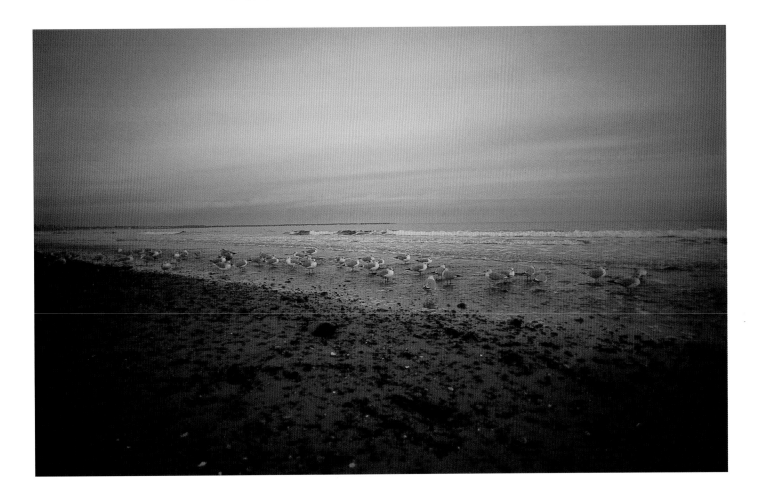

SEAGULLS IN THE SURF AT WELLS BEACH.

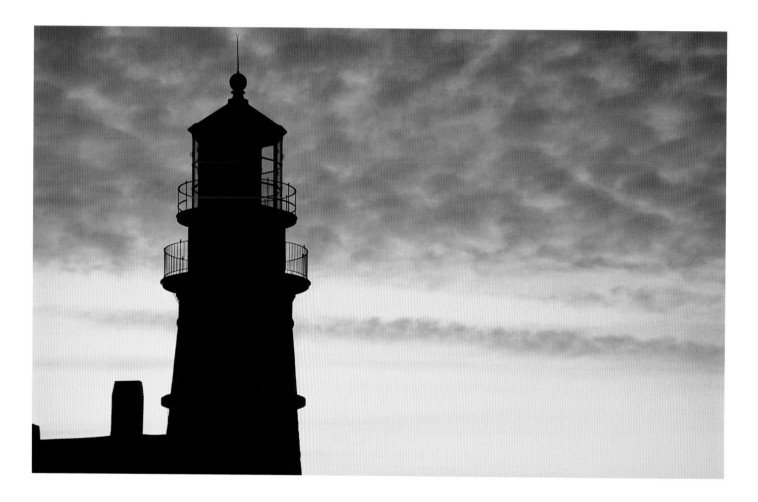

DAWN ILLUMINATING A MACKEREL SKY OVER PORTLAND HEAD LIGHT, CAPE ELIZABETH.

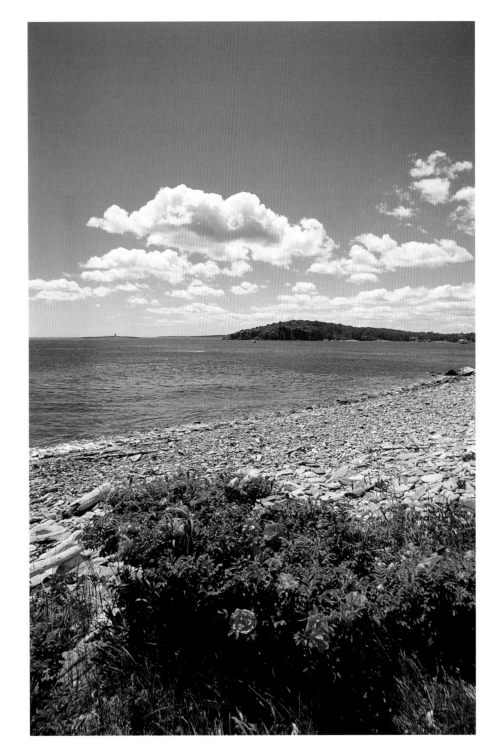

THE BACK SHORE OF
PEAKS ISLAND, LOOKING
TOWARD CUSHING ISLAND.

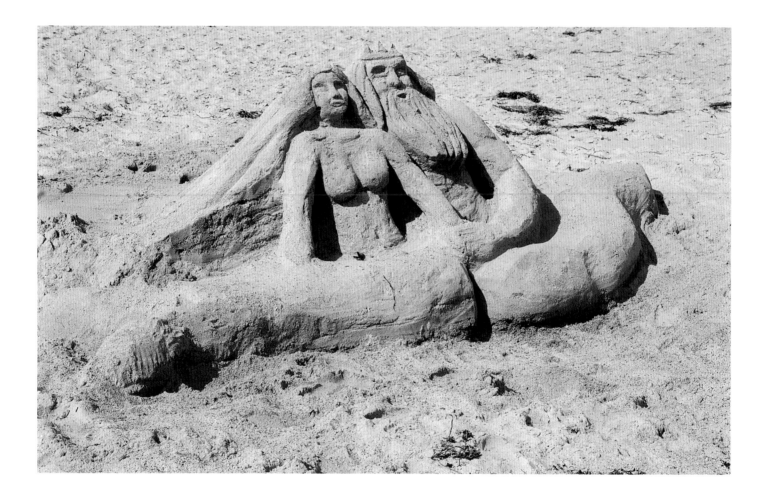

A SAND CASTLE HONORING THE PATRON OF FISHERMEN, KING NEPTUNE,
GOD OF THE SEAS, AND HIS CONSORT, QUEEN AMPHITRITE.

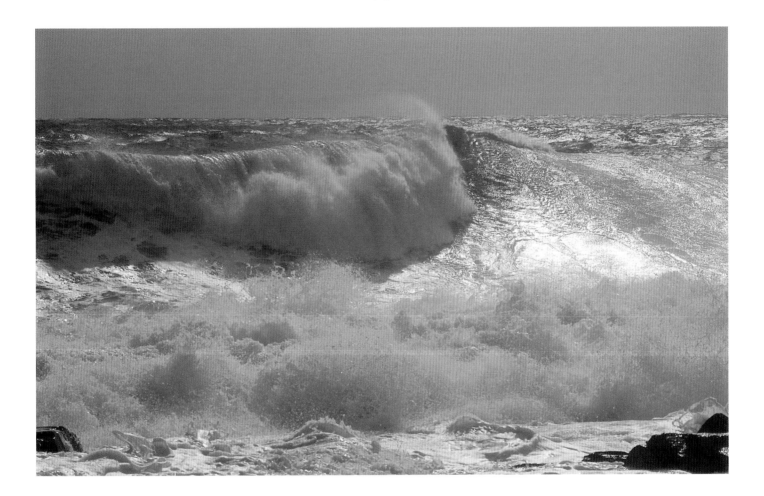

CRASHING SURF IN CAPE ELIZABETH.

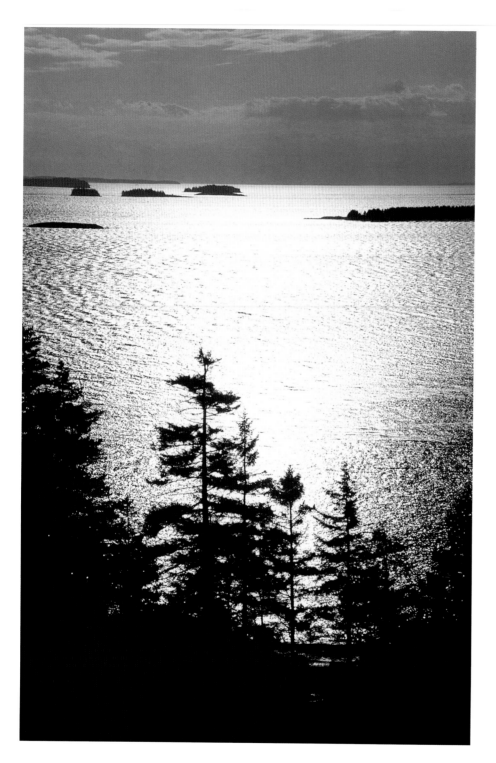

A VIEW OF PENOBSCOT BAY
FROM CAPE ROSIER.

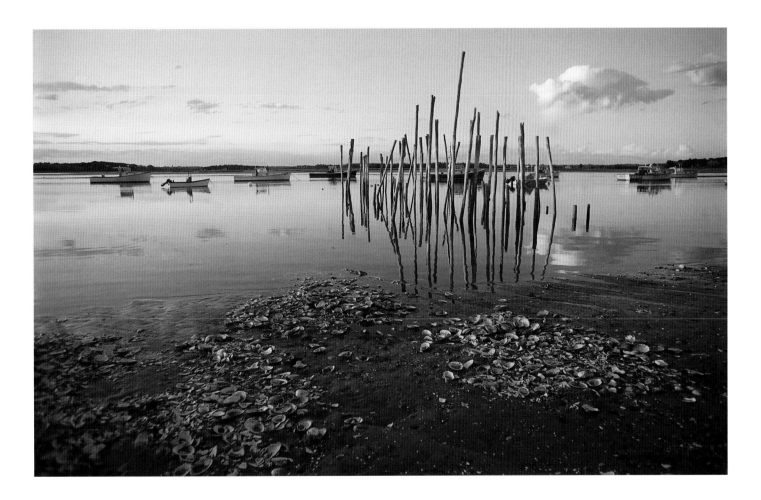

LOBSTER BOATS AT PINE POINT, SCARBOROUGH.

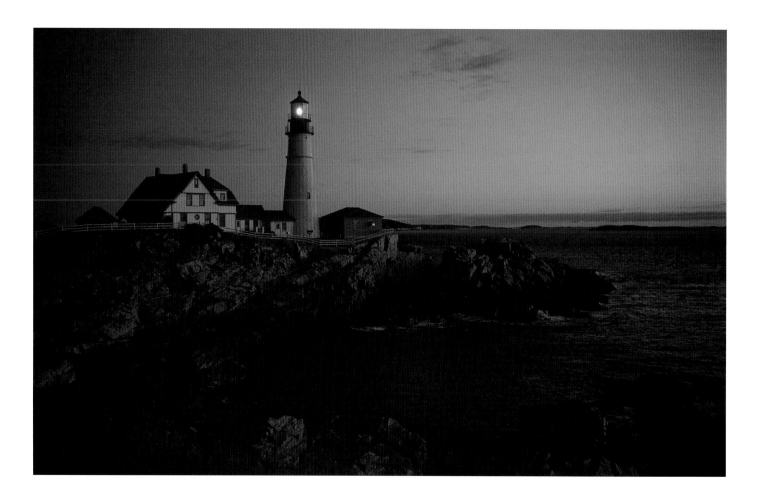

DAWN AT PORTLAND HEAD LIGHT, CAPE ELIZABETH.
BUILT IN 1790, THE ORIGINAL TOWER WAS LIT WITH SIXTEEN WHALE-OIL LAMPS.

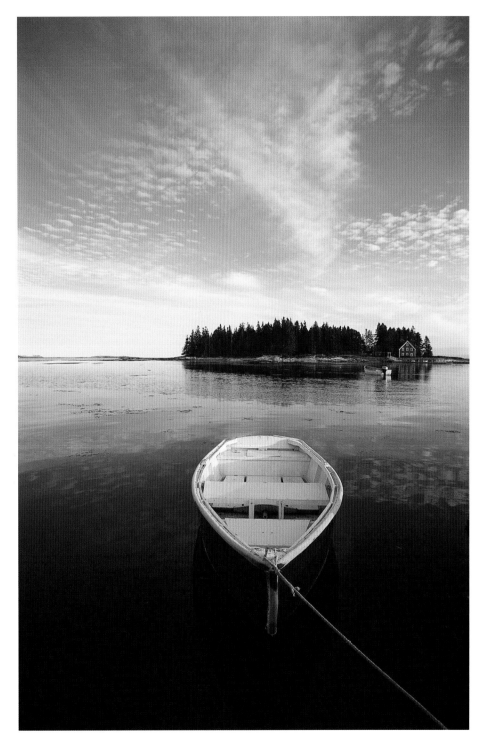

A VIEW OF CAPE ISLAND,
FROM NEWAGEN.

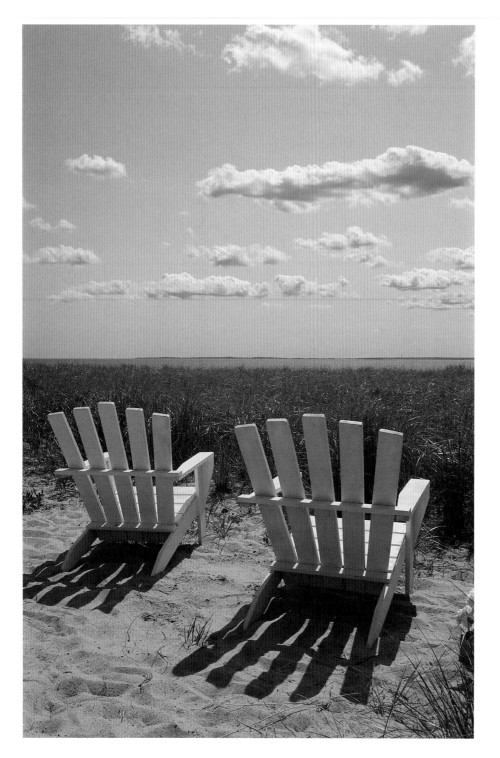

PINE POINT BEACH,
SCARBOROUGH.

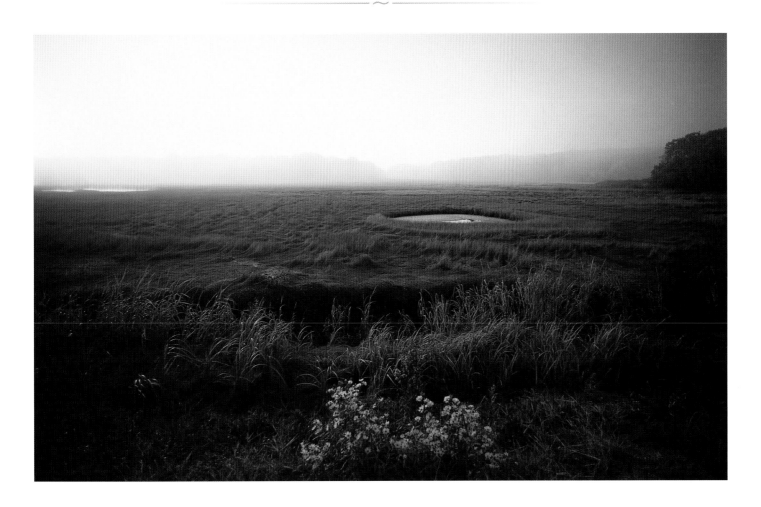

A FALL SUNSET ON THE MARSH, CAPE ELIZABETH.

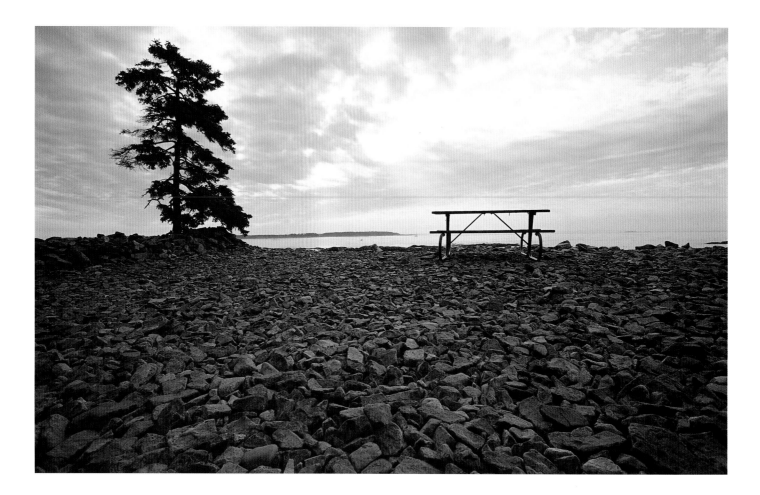

A PICNIC TABLE AT THE NATURAL WALL OF STONES THAT IS SEAWALL BEACH, MT. DESERT ISLAND.

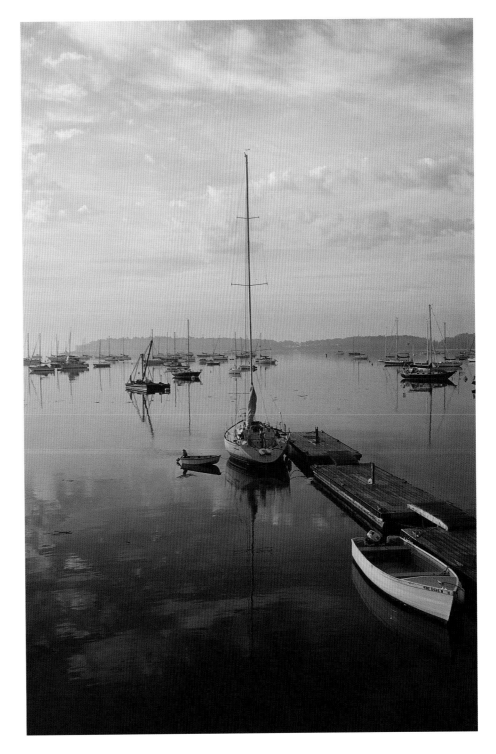

A SAILBOAT AT A WHARF
IN FALMOUTH FORESIDE.

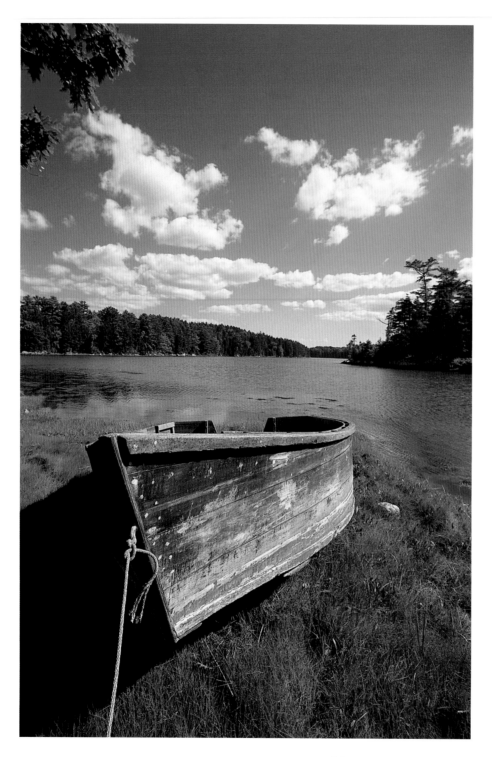

AN OLD BOAT ON
KNICKERKANE ISLAND,
BOOTHBAY.

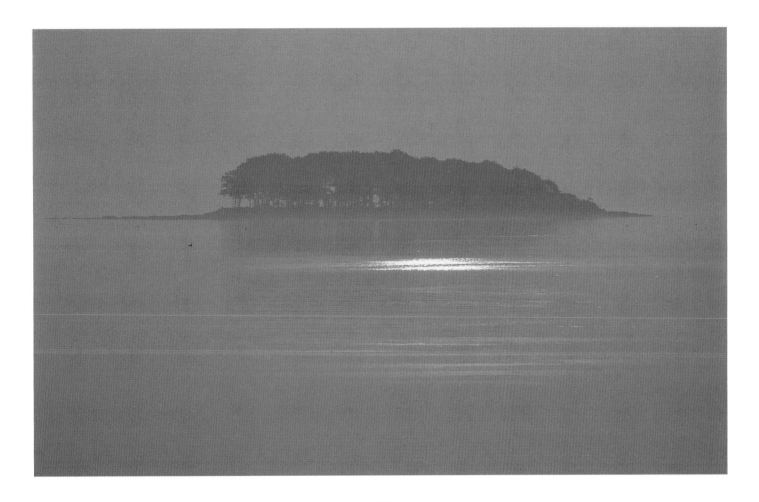

SUNRISE AT BROTHERS ISLAND IN CASCO BAY.

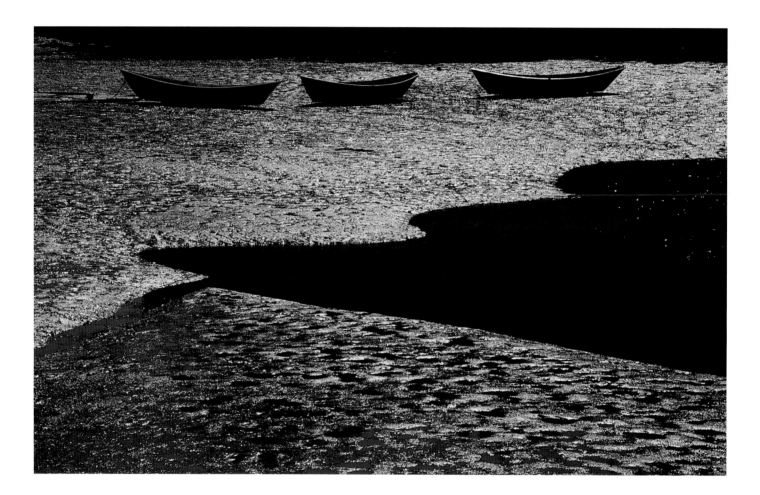

THREE DORIES IN KENNEBUNK. BUILT TO A TIME-HONORED DESIGN,
THESE BOATS ARE STILL USED IN MAINE'S DWINDLING HERRING FISHERY.

SUNRISE ON THE PORCH
OF THE FORMER
ALBONEGON INN, CAPITOL
ISLAND, SOUTHPORT.

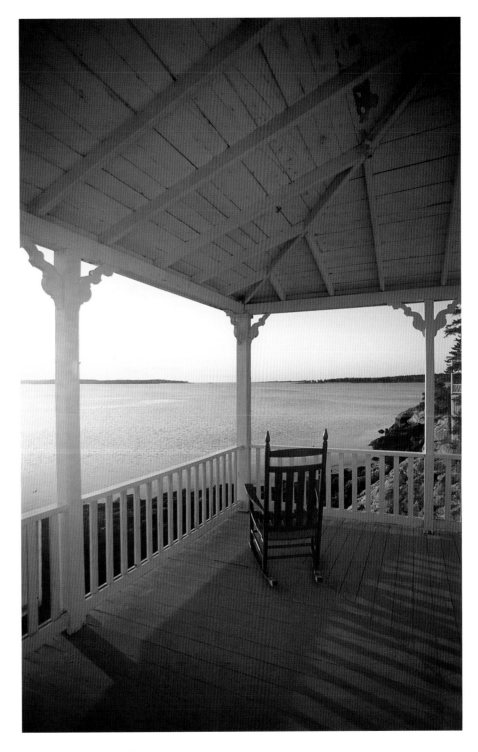

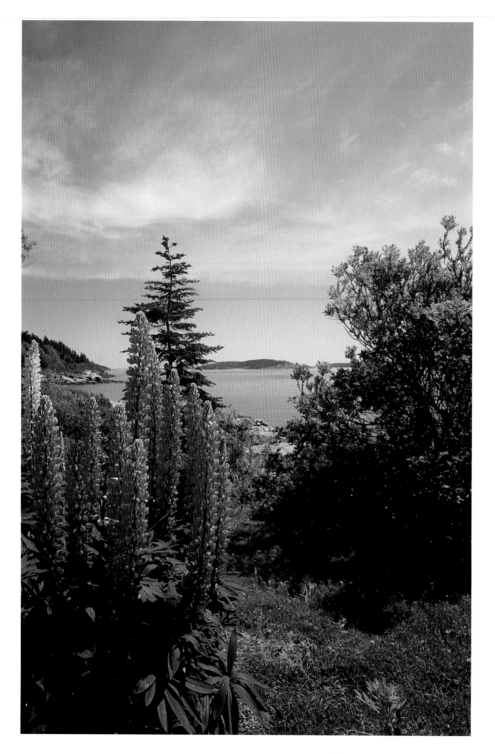

LUPINES ON LONG ISLAND,
CASCO BAY.

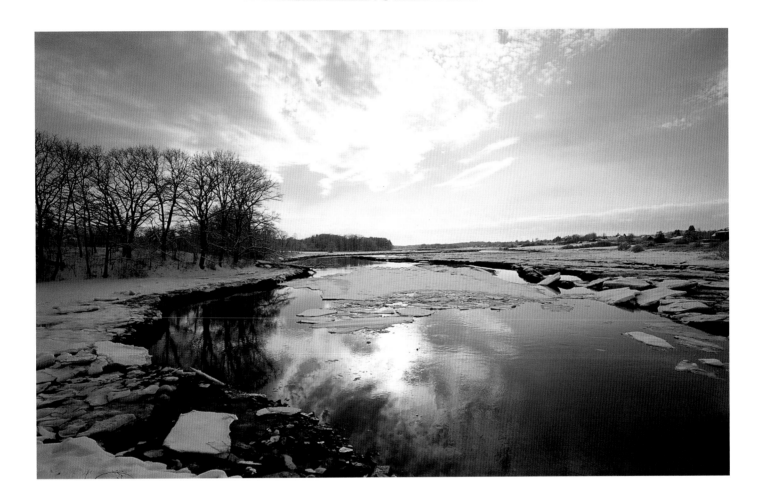

A MARSH IN WINTER ALONG THE SPURWINK RIVER, CAPE ELIZABETH.

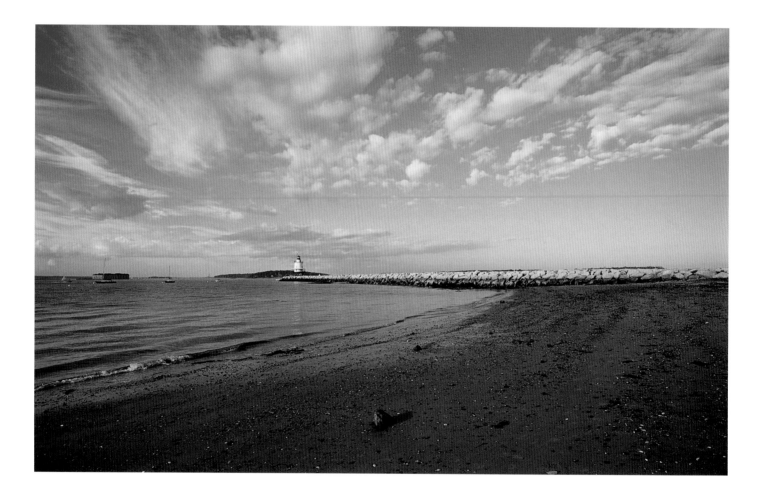

A BEACH NEAR THE BREAKWATER THAT CONNECTS SPRING POINT LEDGE LIGHT TO SOUTH
PORTLAND. IT WAS CONSTRUCTED IN 1951 WITH FIFTY THOUSAND TONS OF GRANITE.

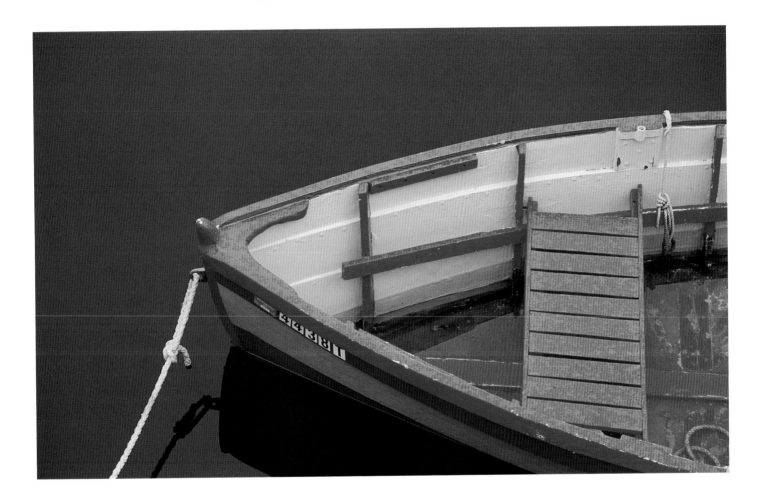

A COLORFUL WORK SKIFF IN PORTLAND.

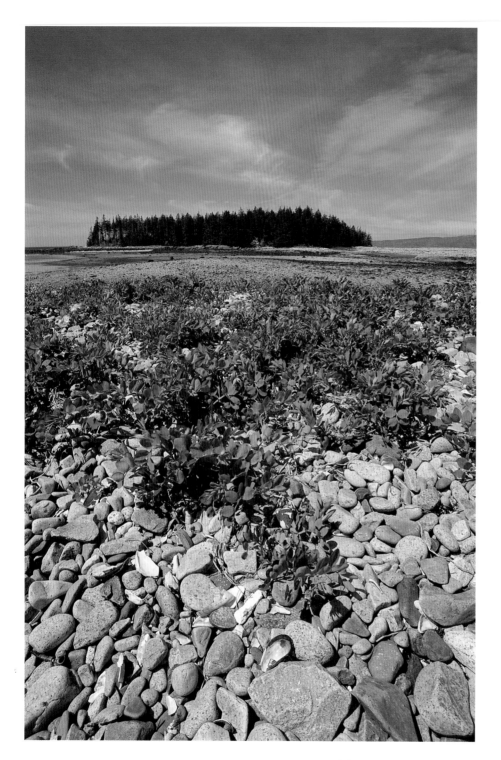

BEACH PEAS ON
THE SHORE, ACADIA
NATIONAL PARK,
SCHOODIC PENINSULA.

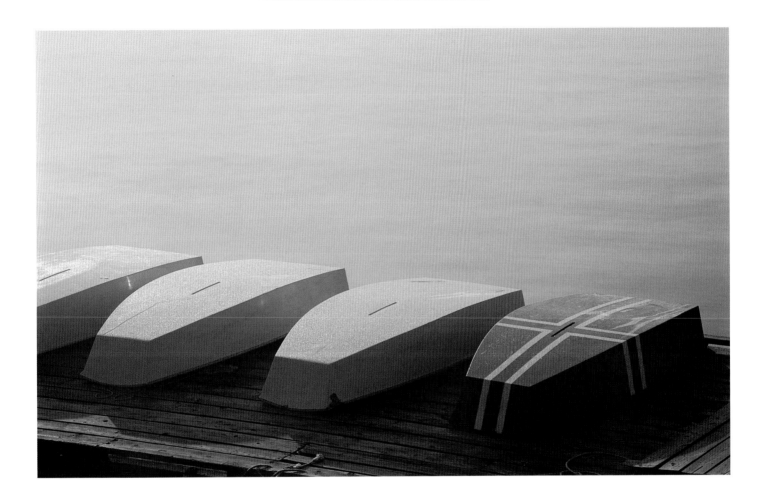

SAILING DINGHIES ON A FLOAT IN FALMOUTH.

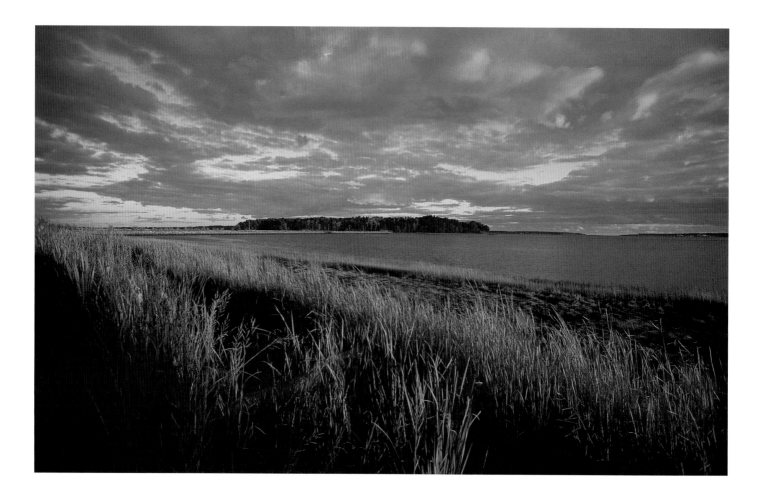

LATE AFTERNOON ON A FALL DAY, LOOKING TOWARD MACKWORTH ISLAND.

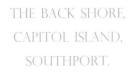

THE BACK SHORE,
CAPITOL ISLAND,
SOUTHPORT.

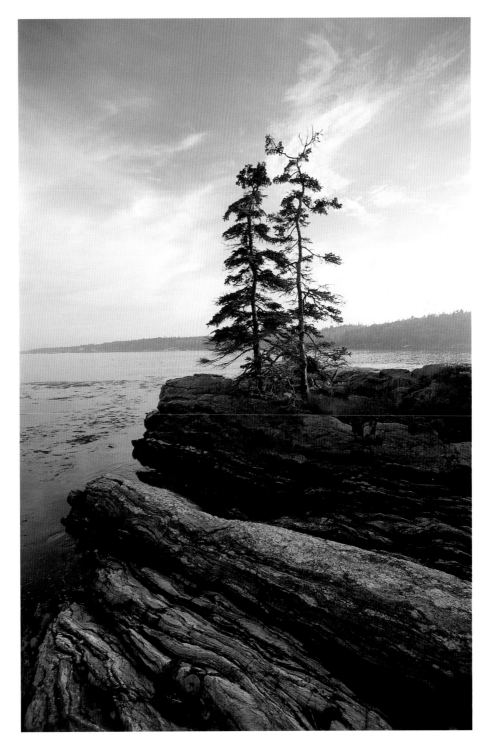

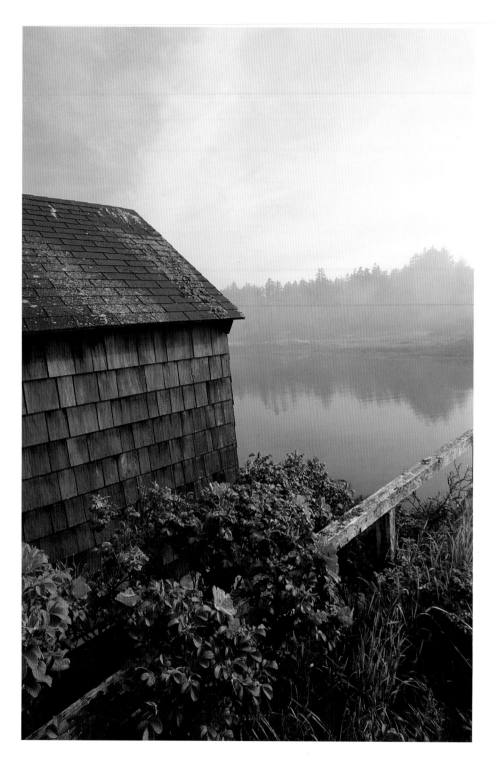

AN ARTIST'S STUDIO IN
COZY HARBOR, SOUTHPORT,
WITH PRATTS ISLAND
IN THE DISTANCE

THE PORTLAND SKYLINE AT DUSK, LOOKING ACROSS THE FORE RIVER FROM SOUTH PORTLAND.

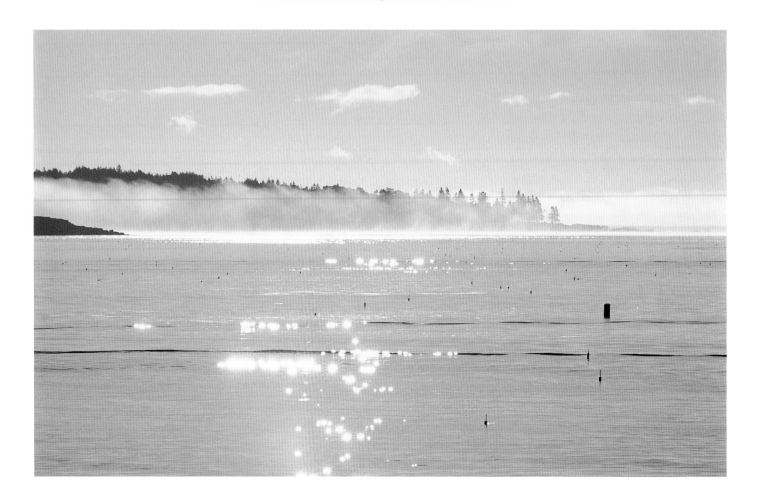

A MISTY MORNING ON LINEKIN BAY.

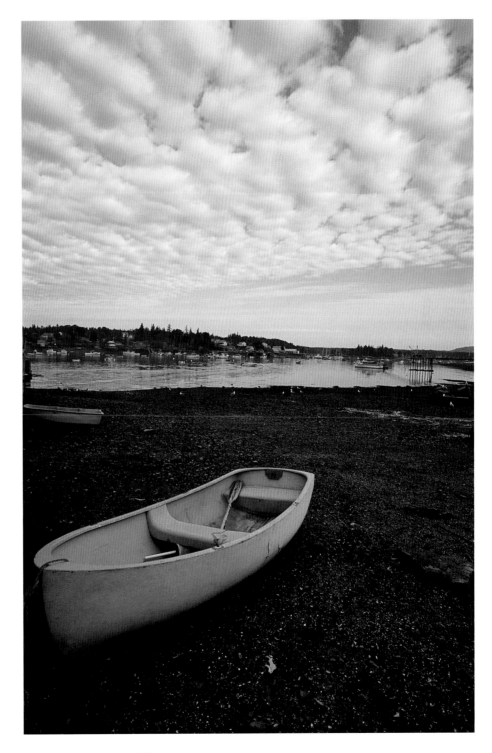

TWO FISHERMEN'S SKIFFS
GROUNDED OUT AT LOW
TIDE IN BASS HARBOR ON
MT. DESERT.

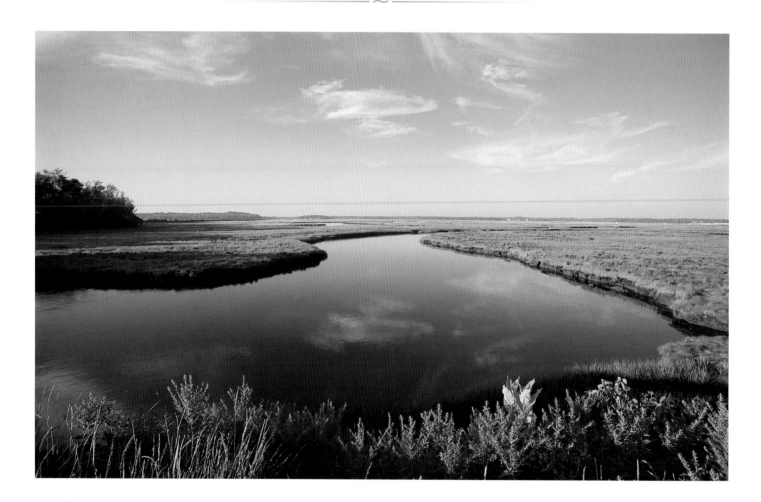

SCARBOROUGH MARSH ON A WINDLESS DAY.

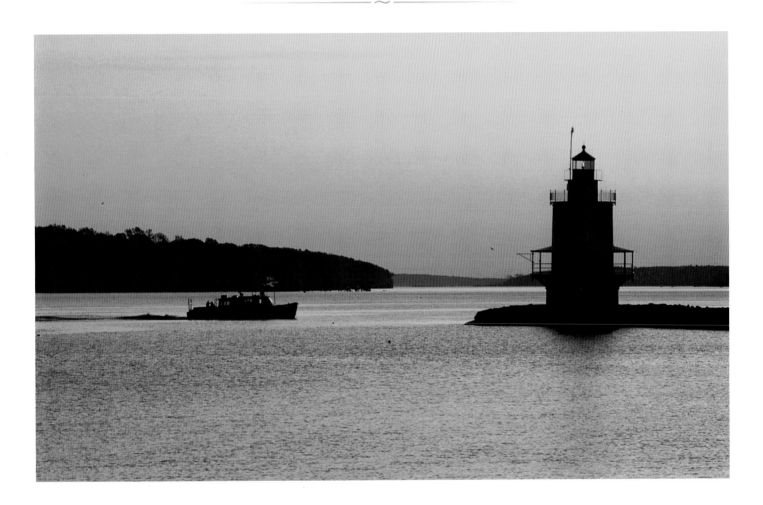

A BOAT PASSES SPRING POINT LEDGE LIGHT, SOUTH PORTLAND, AT DAWN.

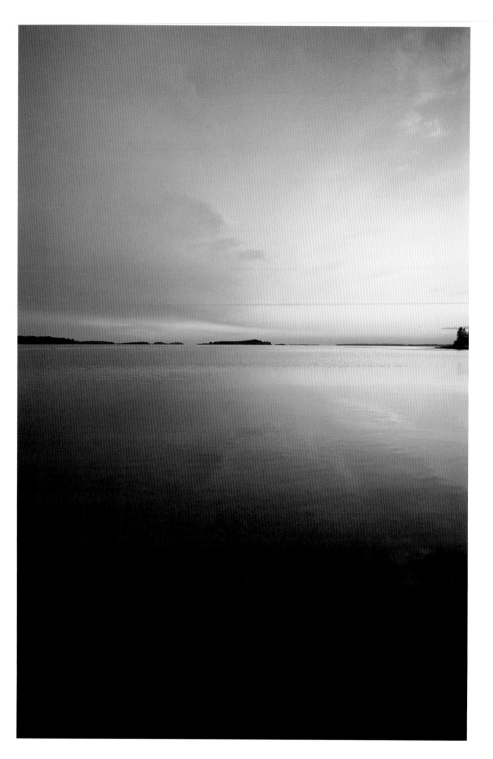

SUNSET AT CAPE ROSIER
FROM THE HEAD OF
THE CAPE.

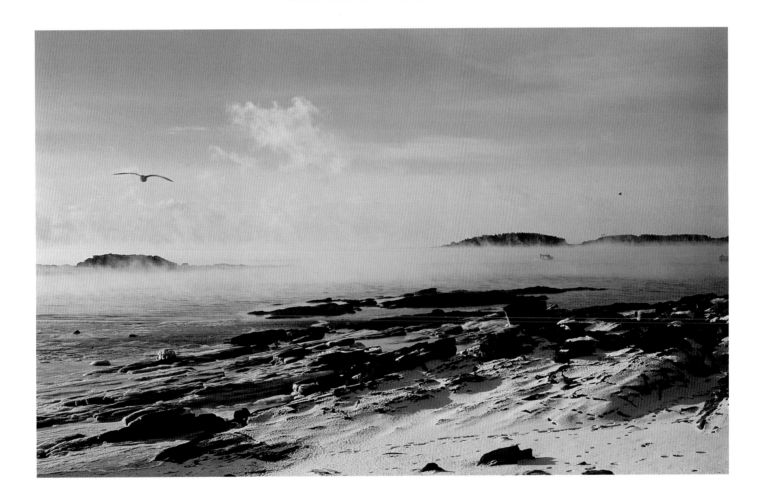

SEA SMOKE IN KETTLE COVE, CAPE ELIZABETH, WITH RICHMOND ISLAND IN THE BACKGROUND.

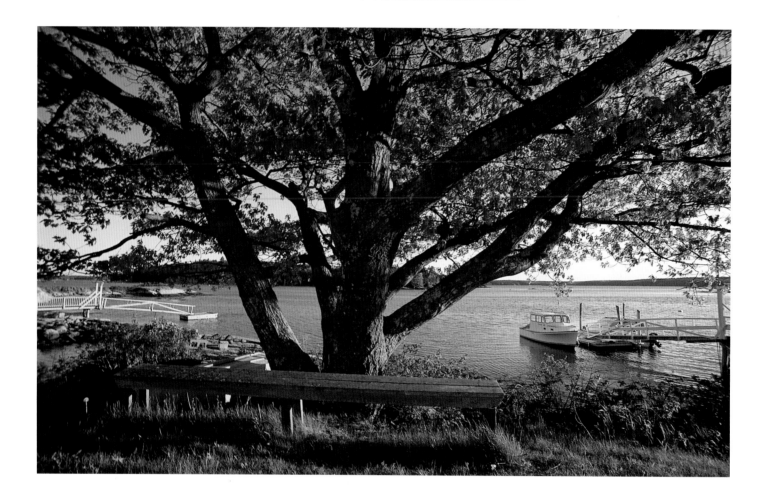

THE VIEW TOWARD THE ISLE OF SPRINGS.

LOW TIDE AT CRESCENT
BEACH, CAPE ELIZABETH.

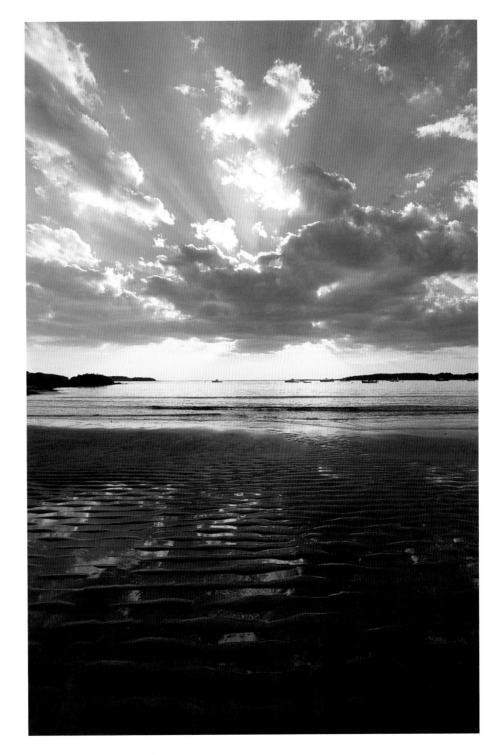

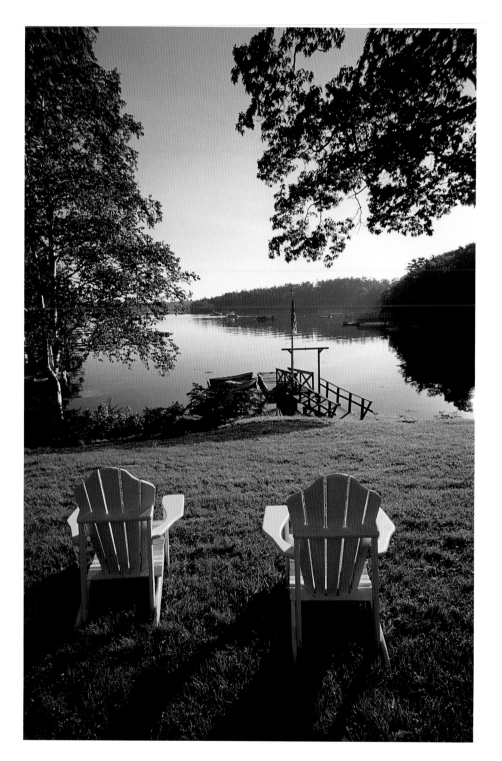

AN EARLY MORNING
VIEW OF THE WHARF
AT THE LAWNMERE INN,
SOUTHPORT ISLAND.
WHEN THE INN FIRST
OPENED IN 1898, GUESTS
ARRIVED BY STEAMBOAT.

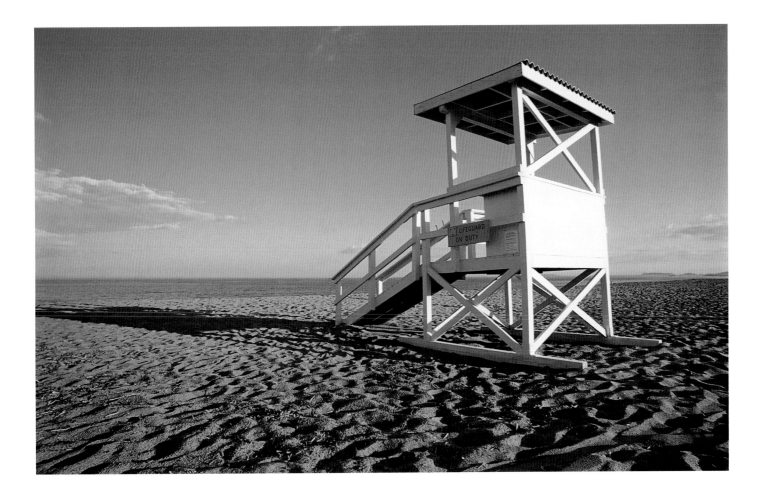

LIFEGUARD CHAIR, REID STATE PARK, GEORGETOWN.

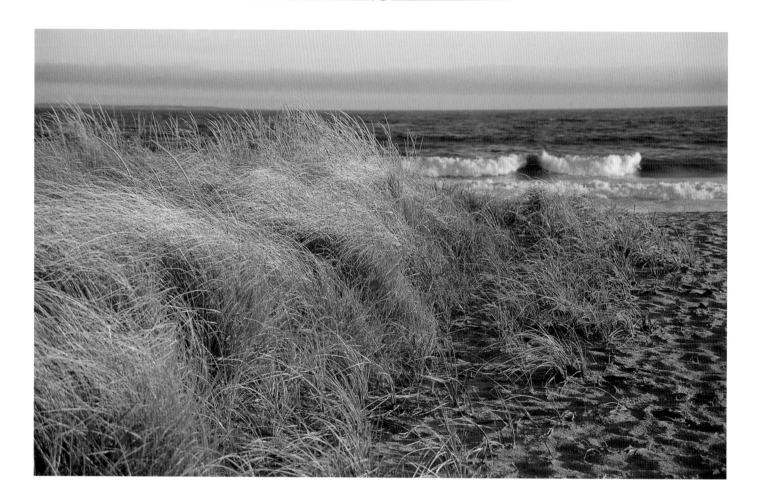

DUNE GRASS AT PINE POINT BEACH, SCARBOROUGH.

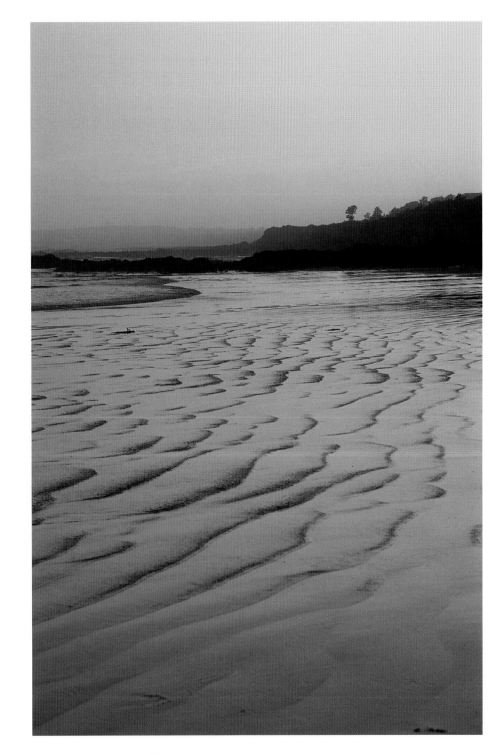

RIPPLED SAND AT SUNSET,
HIGGINS BEACH,
SCARBOROUGH.

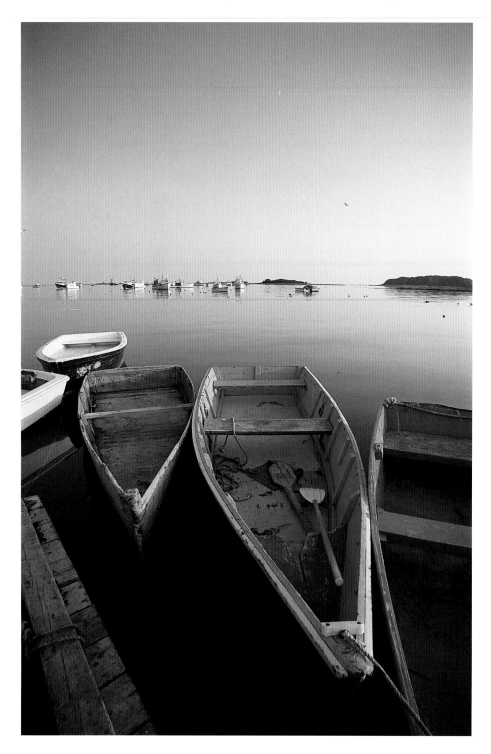

ROWBOATS TIED TO
A WHARF IN CAPE
PORPOISE HARBOR.

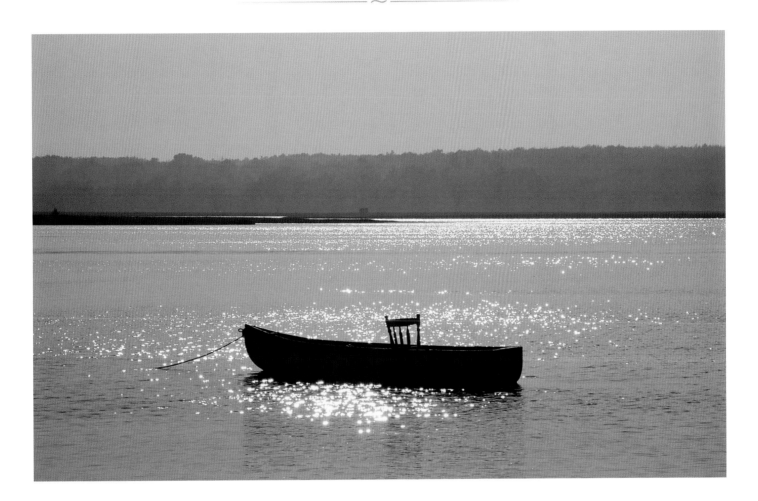

A SKIFF WITH AN UNORTHODOX SEAT, MOORED OFF PINE POINT, SCARBOROUGH.

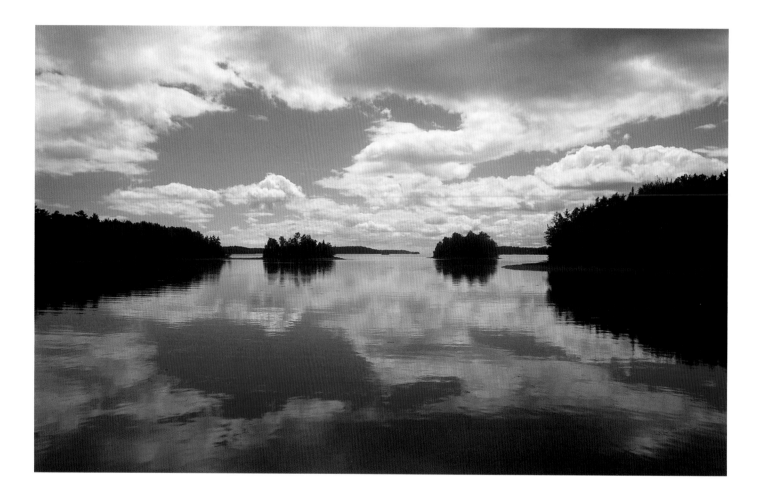

A VIEW OF HARPSWELL SOUND.

SEA SMOKE ON THE
PRESUMPSCOT RIVER, FALMOUTH.
THIS PHENOMENON OCCURS ON
FRIGID DAYS WHEN THE AIR IS
COLDER THAN THE WATER.

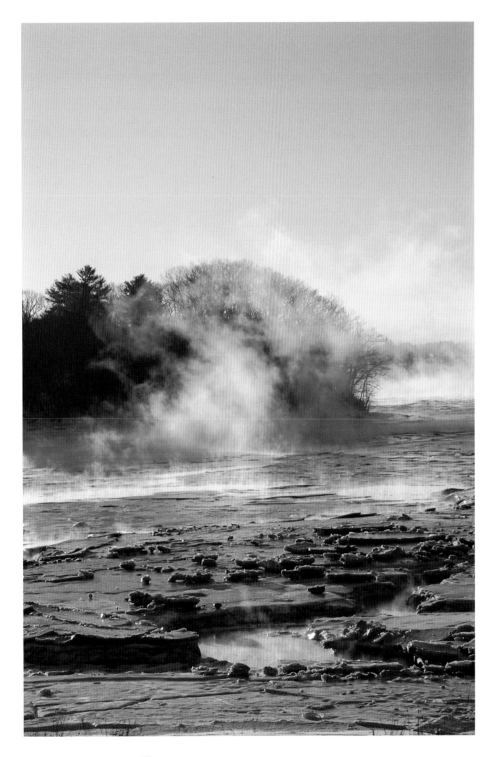

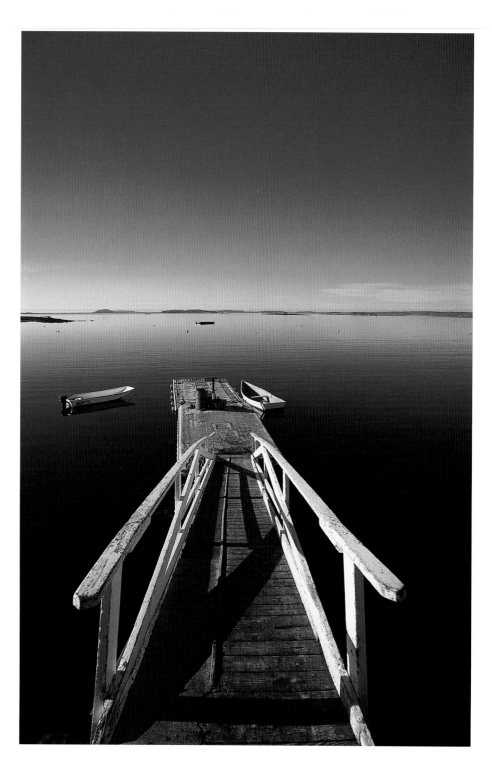

EARLY MORNING AT A
WHARF IN POTTS HARBOR,
SOUTH HARPSWELL.

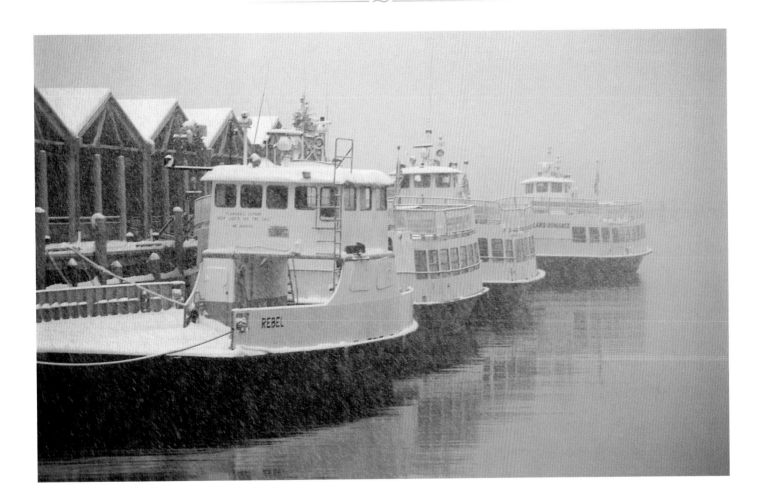

CASCO BAY LINES' FERRIES IN THE SNOW, MAINE STATE PIER, PORTLAND.
THE FERRY COMPANY, WHICH TRANSPORTS MORE THAN ONE MILLION PEOPLE ANNUALLY,
DATES BACK TO THE CASCO BAY STEAMBOAT COMPANY, FOUNDED IN 1878.

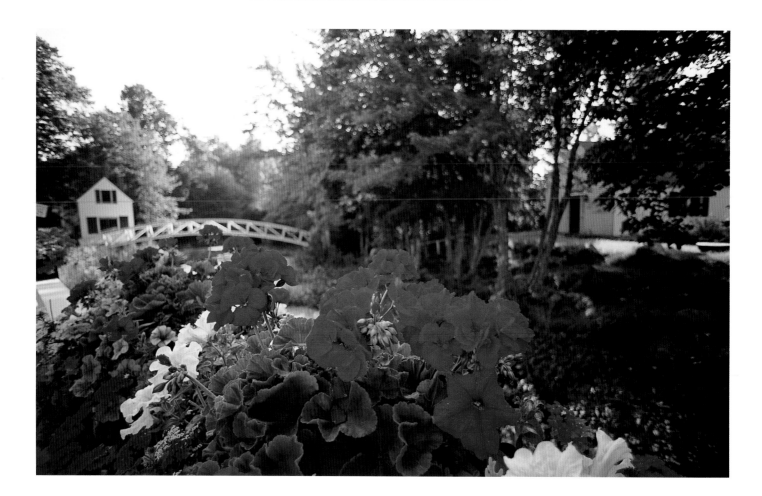

THE WALKING BRIDGE IN SOMESVILLE, MT. DESERT ISLAND. THE VILLAGE IS NAMED AFTER
ABRAHAM SOMES, WHO WAS THE FIRST EUROPEAN TO SETTLE THERE, IN 1762.

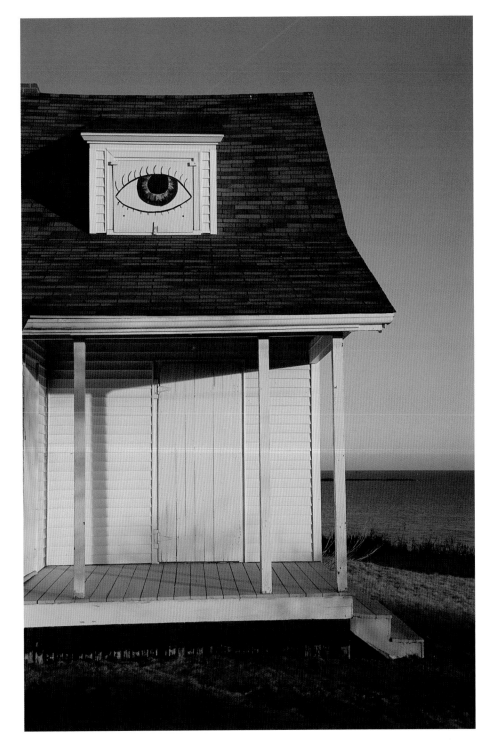

A WHIMSICAL
SHUTTER PAINTING
ON BAILEY ISLAND.

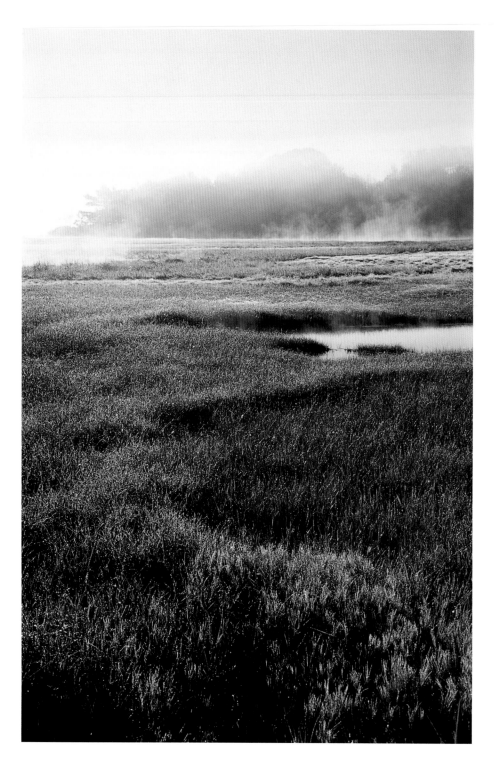

MORNING MIST RISING
OVER MARSH IN THE FALL,
CAPE ELIZABETH.

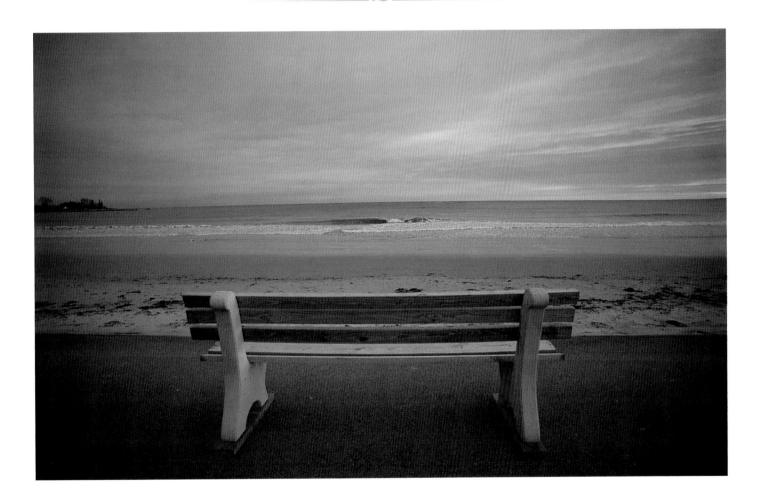

BENCH BY THE SEA, GOOCHS BEACH, KENNEBUNK.

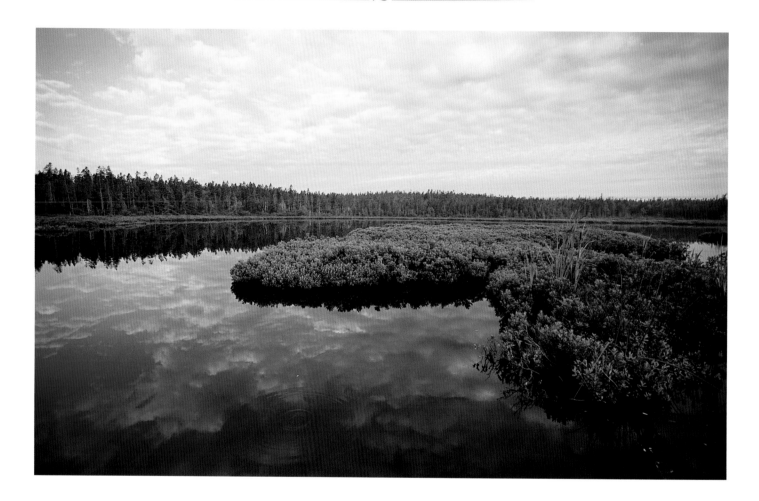

SEAWALL POND, MT. DESERT ISLAND. THE POND WAS CREATED WHEN WAVES
CRASHED OVER THE NEARBY ROCK SEAWALL AND FLOODED THIS LOW-LYING AREA.

FLOWERS ALONG THE
CLIFF WALK, PROUTS NECK,
SCARBOROUGH. ARTIST
WINSLOW HOMER SPENT THE
FINAL TWENTY-EIGHT YEARS
OF HIS LIFE PAINTING IN THE
PROUTS NECK AREA.

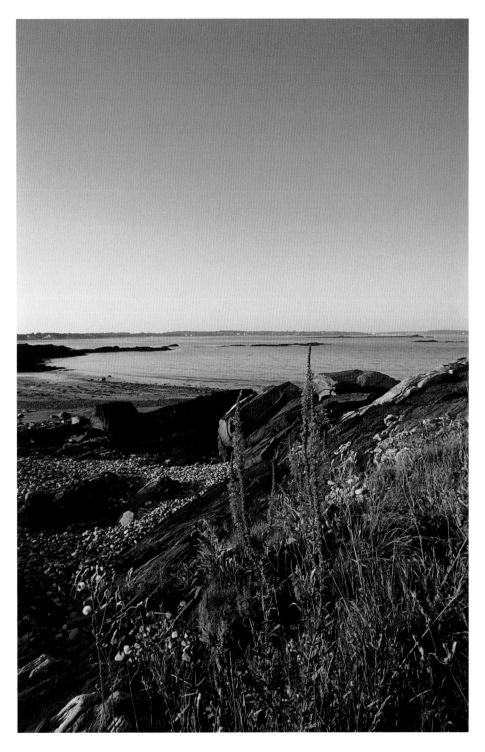

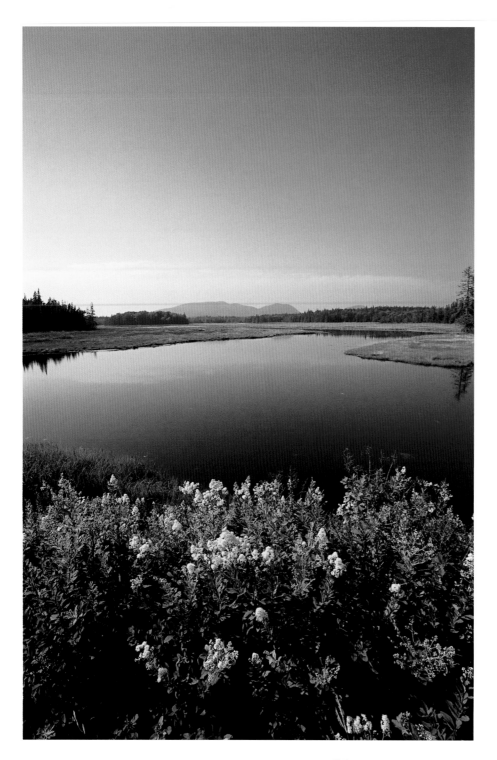

BASS HARBOR MARSH,
MT. DESERT ISLAND, WITH
A VIEW OF BERNARD, MANSELL,
AND BEECH MOUNTAINS

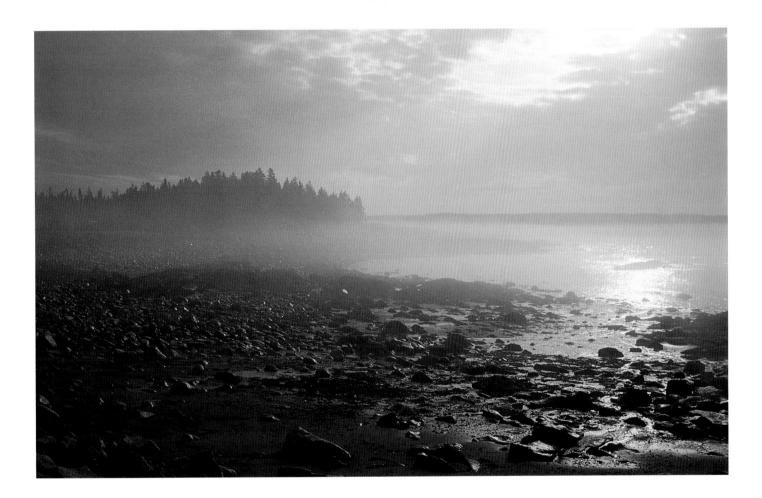

EARLY MORNING FOG ROLLING IN AT SEAWALL, MT. DESERT ISLAND.

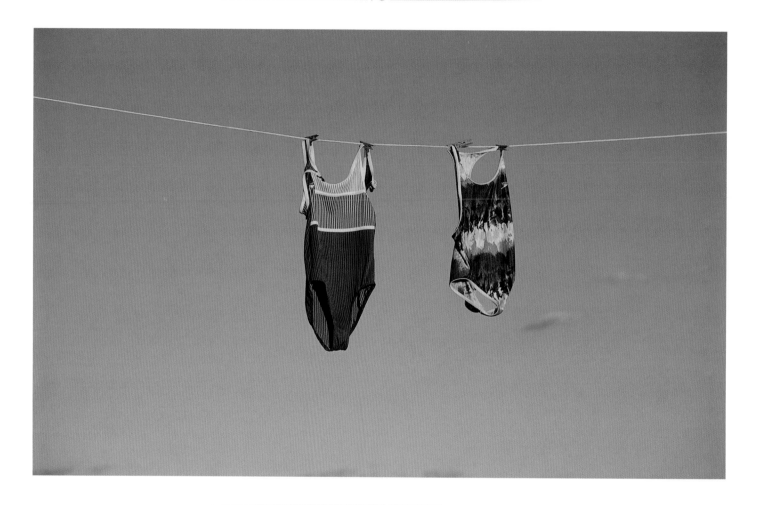

BATHING SUITS HANGING OUT TO DRY, FORTUNES ROCKS BEACH.

PEMAQUID POINT LIGHT,
BRISTOL. THE THIRTY-EIGHT-
FOOT-HIGH STONE TOWER,
BUILT IN 1835, WAS FEATURED
ON THE MAINE STATE QUARTER,
MINTED IN 2003.

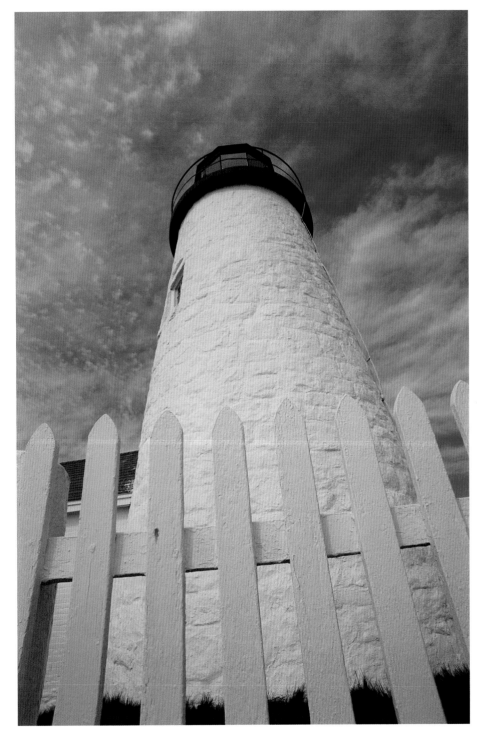

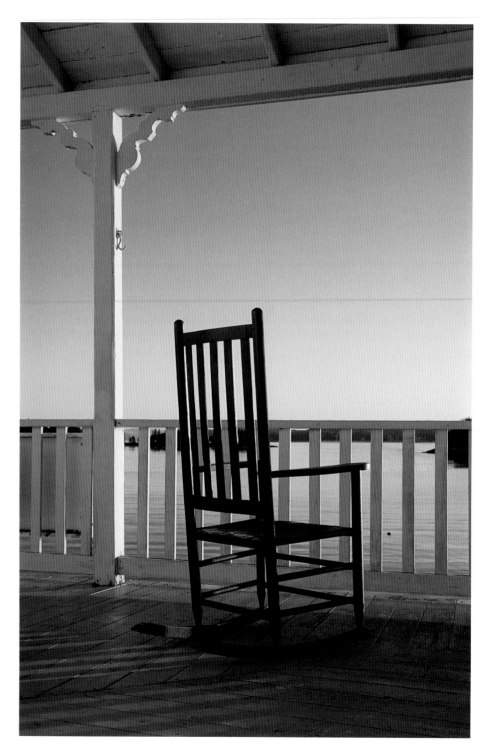

SUNRISE AT CAPITOL
ISLAND, SOUTHPORT.

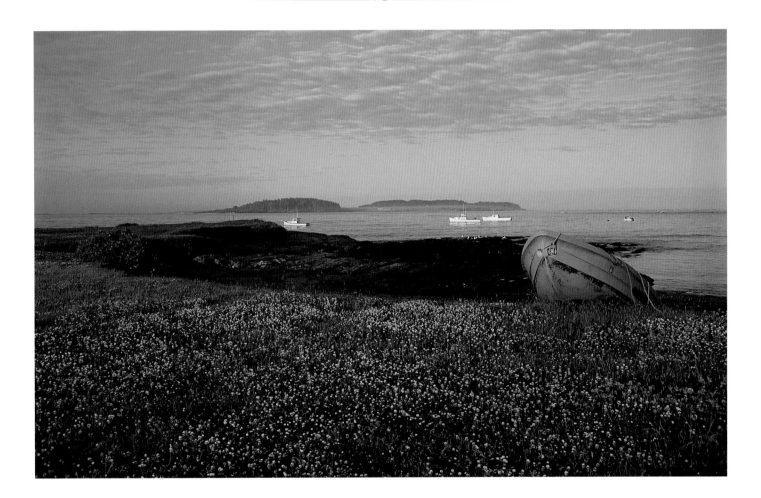

KETTLE COVE, CAPE ELIZABETH, LOOKING TOWARD RICHMOND ISLAND. LOCAL LEGEND SAYS
THERE IS BURIED TREASURE ON THE ISLAND, REPUTEDLY A HOARD GATHERED BY WALTER
BAGNALL, WHO GREW RICH IN THE 1600S TRADING RUM FOR BEAVER PELTS WITH THE LOCAL
NATIVE AMERICANS UNTIL THEY REBELLED, KILLED HIM, AND BURNED HIS TRADING POST.

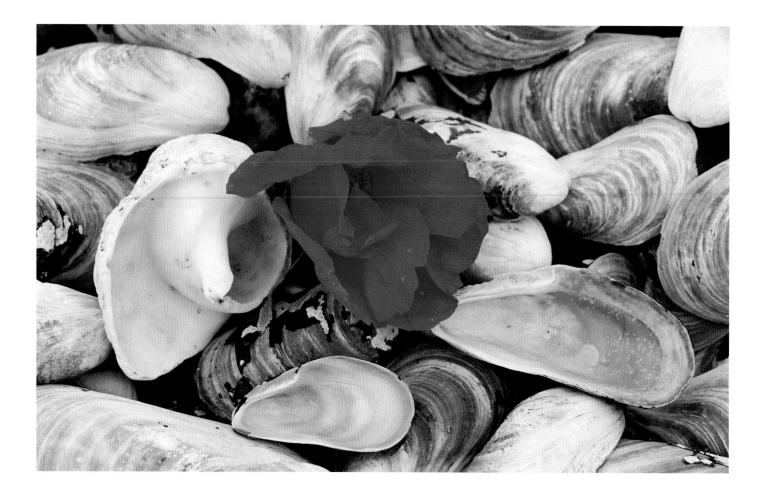

A RUGOSA ROSE BLOSSOM NESTLED IN BLUE MUSSEL SHELLS.

FORTUNES ROCKS BEACH,
BIDDEFORD.

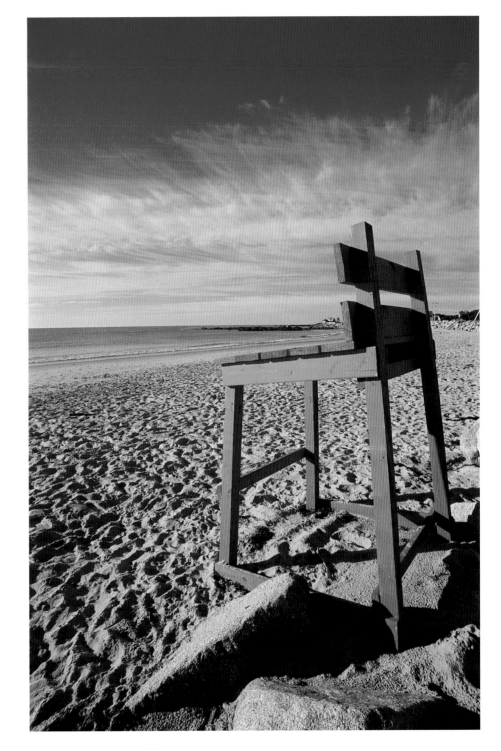

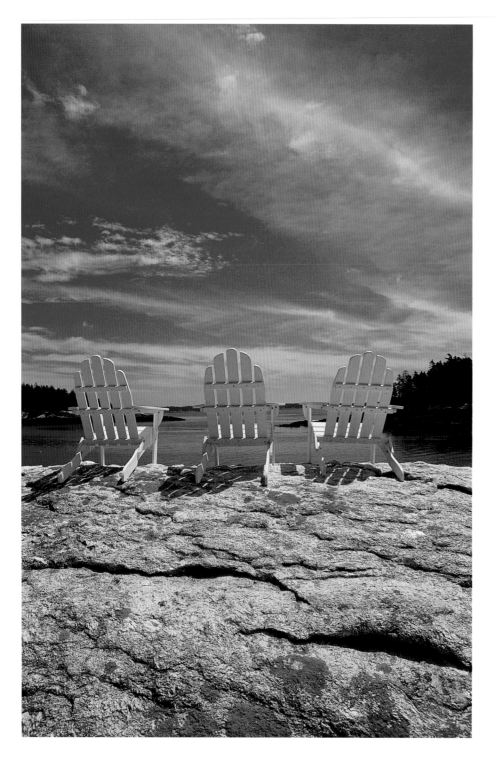

FIVE ISLANDS,
GEORGETOWN ISLAND,
WITH A VIEW OF
SHEEPSCOT BAY.

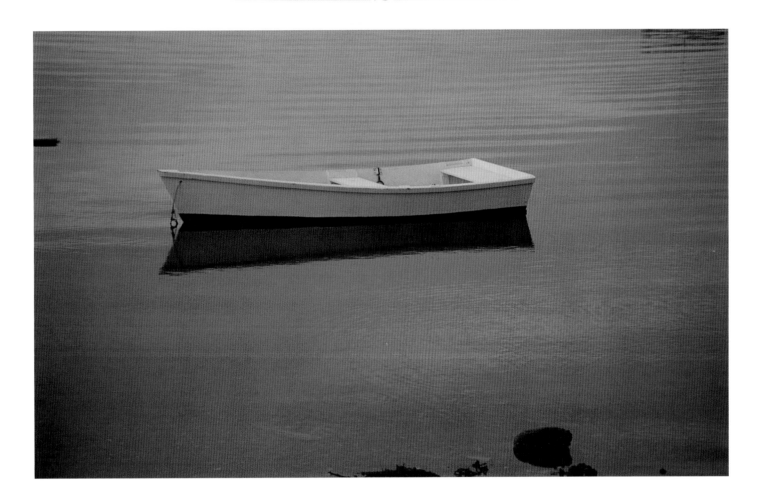

A WOODEN SKIFF AT SUNSET IN COOKS COVE, BAILEY ISLAND.

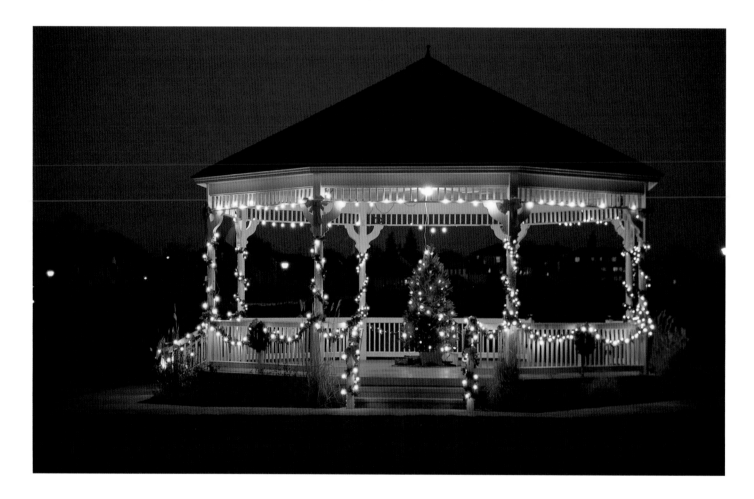

HOLIDAY DECORATIONS ON THE TOWN PAVILION, YORK.

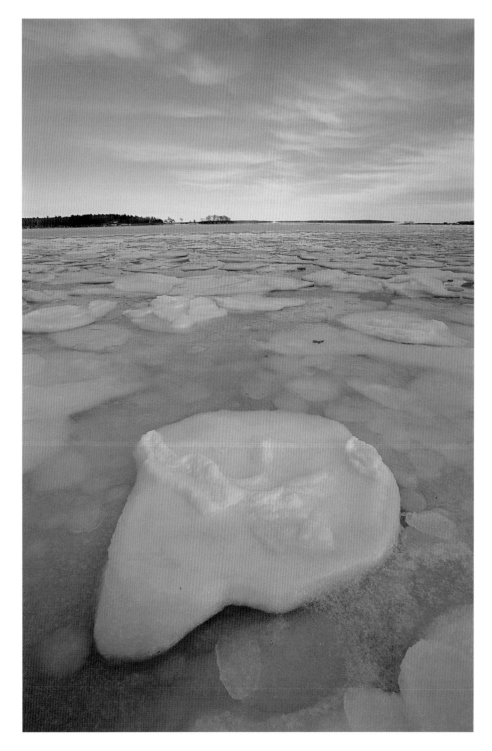

PANCAKE ICE
IN CAMDEN HARBOR.

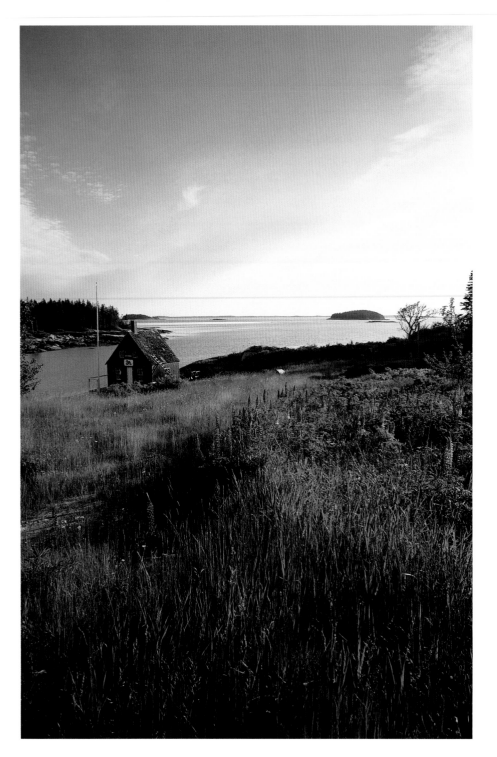

LUPINES AROUND
A FISHING SHACK,
STONINGTON.

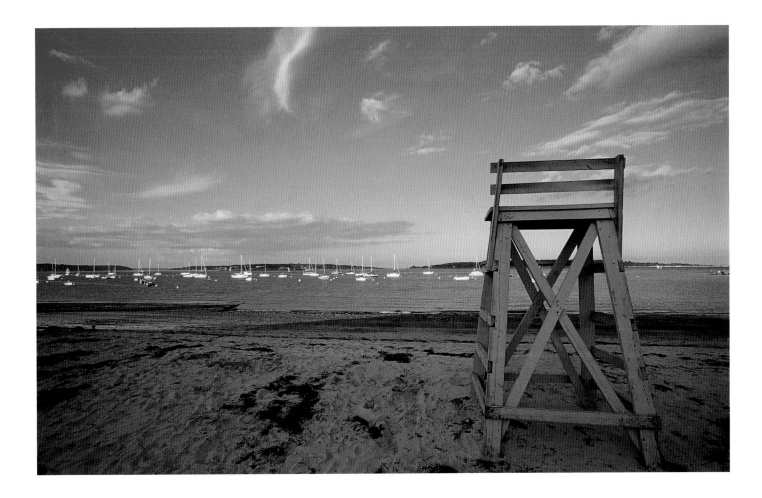

LATE AFTERNOON AT WILLARD BEACH, SOUTH PORTLAND.

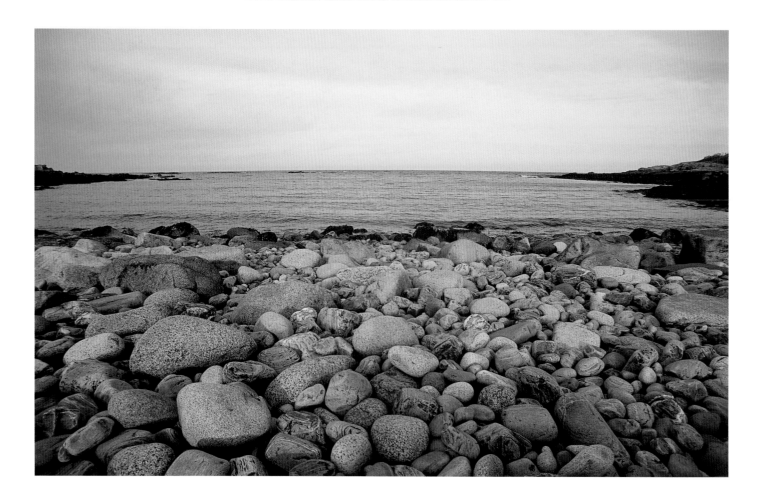

A PEBBLE BEACH ALONG THE CLIFF WALK, PROUTS NECK.

OARS IN A SKIFF AT
COZY HARBOR.

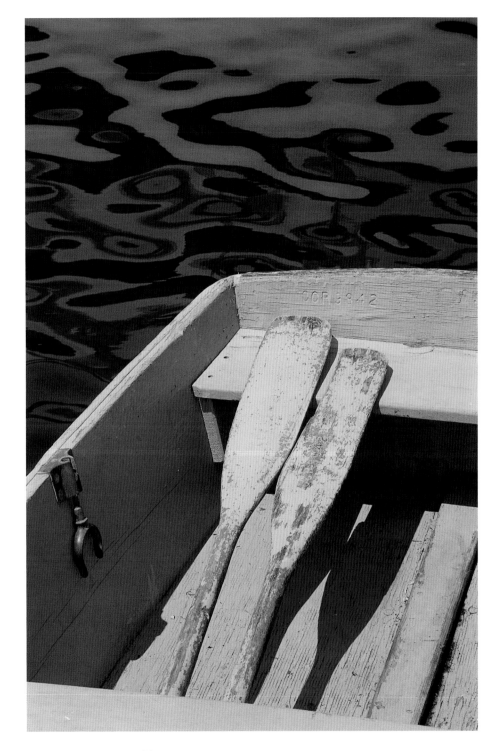

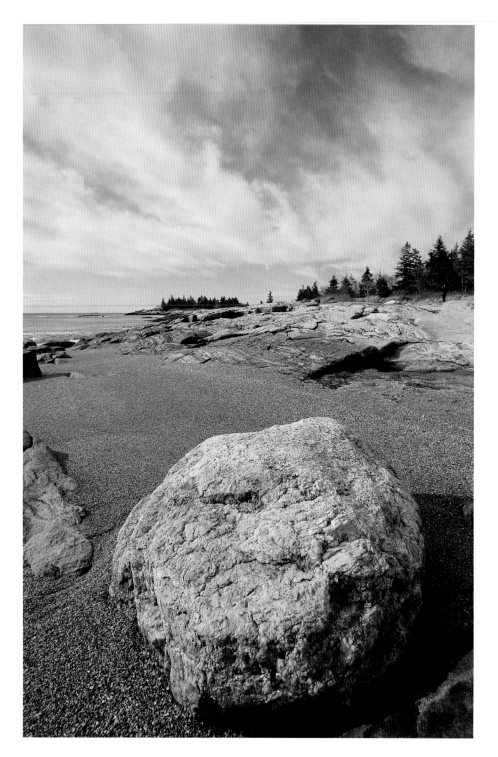

THE LAGOON AT
REID STATE PARK,
GEORGETOWN.

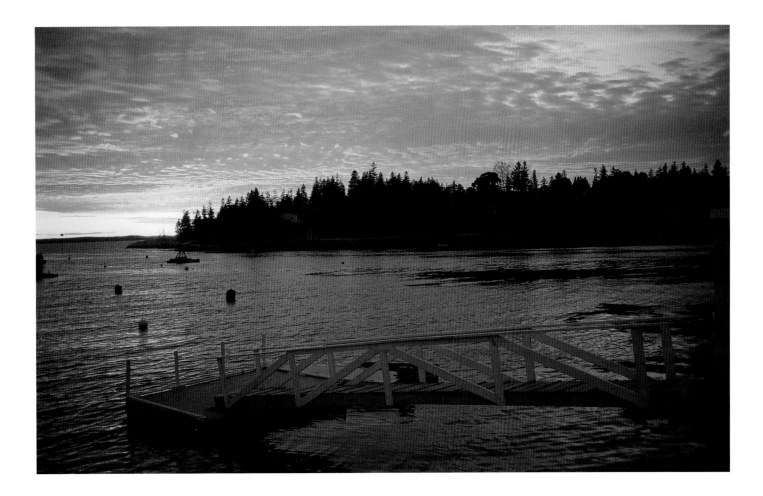

CAPE HARBOR, NEWAGEN.

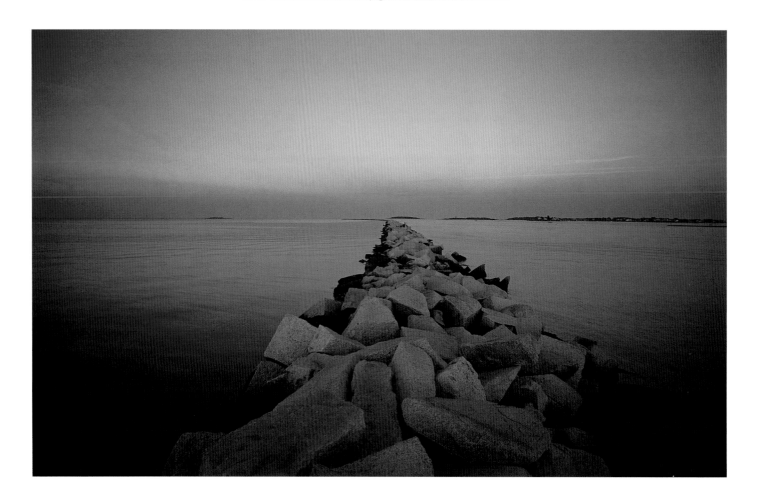

JETTY AT DUSK, CAMP ELLIS.

THE FLOWER
GARDEN AT THE
OCEAN POINT INN,
EAST BOOTHBAY.

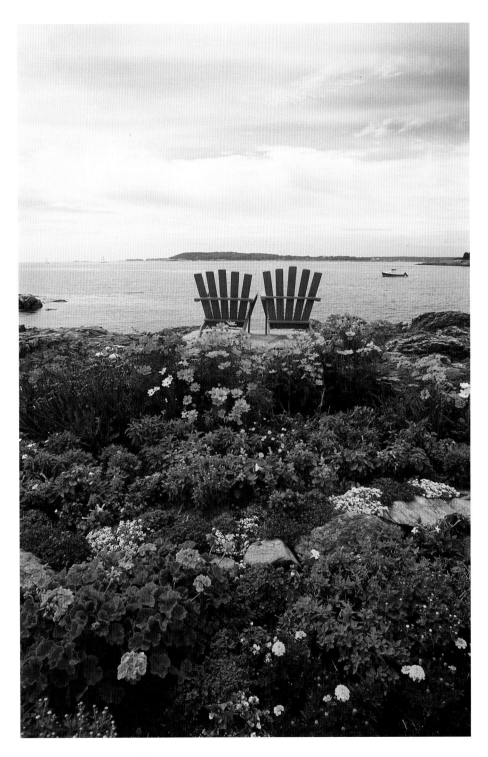

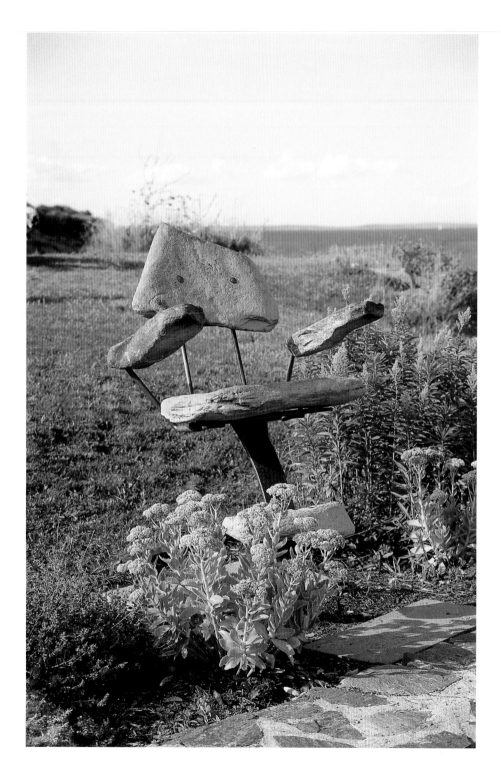

AN EXAMPLE OF MAINE
RESOURCEFULNESS: A CHAIR
MADE OUT OF BEACH
STONES AT THE LOBSTER
SHACK, CAPE ELIZABETH.